**FEDERICO ZERI** (Rome, 1921-1998), eminent art historian and critic, was vice-president of the National Council for Cultural and Environmental Treasures from 1993. Member of the Académie des Beaux-Arts in Paris, he was decorated with the Legion of Honor by the French government. Author of numerous artistic and literary publications; among the most well-known: *Pittura e controriforma*, the Catalogue of Italian Painters in the Metropolitan Museum of New York and the Walters Gallery of Baltimore, and the book *Confesso che ho sbagliato*.

## Work edited by FEDERICO ZERI

**Text**
based on the interviews between
FEDERICO ZERI and MARCO DOLCETTA

This edition is published for North America in 1999 by NDE Publishing*

**Chief Editor of 1999 English Language Edition**
ELENA MAZOUR (*NDE Publishing**)

**English Translation**
RAMAN A. MONTANARO

**Realisation**
CONFUSIONE S.R.L., ROME

**Editing**
ISABELLA POMPEI

**Desktop Publishing**
SIMONA FERRI, KATHARINA GASTERSTADT

ISBN 1-55321-006-9

## Illustration references

**Alinari archives:** 23, 25, 32, 40l-r, 44/II-V.

**Alinari archives/Giraudon:** 35, 44/X.

**Bridgeman/Alinari archives:** 7b, 26b, 31, 33bl, 36l, 38, 44III-VIII, 45/XII.

**Giraudon/Alinari archives:** 4b, 9tr-br, 37, 41br, 43t-b, 44/IX, 45/VI-XI.

**Luisa Ricciarini Agency:** 1, 2-3, 4t, 4-5, 6, 7tl-r, 8-9, 9tl-c, 10, 11l-r, 12t, 12-13, 14t-b, 14-15, 16t-c, 16-17, 20t, 34, 36r, 44/IV, 45/VII-XIII.

**RCS Libri Archives:** 18b, 19, 21l, 28-29, 29, 30b, 33cl-tr, 41t, 44/VII, 45/II-III-IV-V.

**R.D.:** 2, 12b, 16b, 18t, 20b, 21r, 22l-r, 24t-b, 26t, 27, 30t, 33tl-br, 39t-b, 41c-bl, 42t-b, 44/I-VI-XI-XII, 45/I-VIII-IX-X-XIV.

Printed and bound by Poligrafici Calderara S.p.A., Bologna, Italy

* a registered business style of NDE Canada Corp.
18-30 Wertheim Court, Richmond Hill, Ontario
L4B 1B9 Canada, tel. (905) 731-12 88

*The captions of the paintings contained in this volume include, beyond just the title of the work, the dating and location. In the cases where this data is missing, we are dealing with works of uncertain dating, or whose current whereabouts are not known. The titles of the works of the artist to whom this volume is dedicated are in blue and those of other artists are in red.*

# RUBENS
# GARDEN OF LOVE

The painting represents a synthesis of Ruben's formal and artistic journey, and reveals the prodigious technical control of the master. Notwithstanding the evident complexity of the figurative plot, articulated in various episodes, in THE GARDEN OF LOVE everything seems to be re-

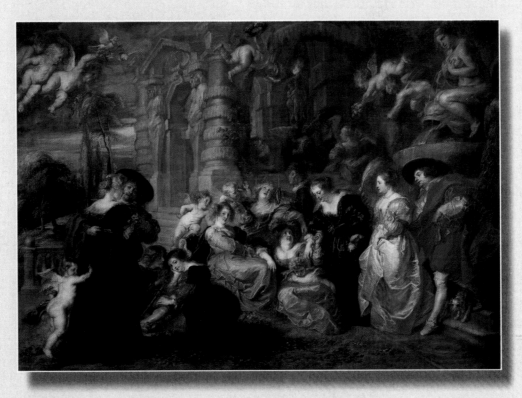

solved with extreme ease. The composition is no longer mannerist, in which the figures are motionless in static space; the dynamism of the characters transmits itself to the architecture and the landscape, reverbrating across the entire surface of the canvas.

# THE CELEBRATION OF A PRIVATE HAPPINESS

● Madrid, Prado Museum (oil on canvas, 198cm x 283cm) *circa 1632-33.*

● The painting, bequeathed to the Alcazar of Madrid in 1640, decorated the bedroom in which King Philip IV died in 1655. The canvas was realized by the painter without any commission whatsoever. It coincides with a period of renewed well-being in the artist, inaugurated by his second marriage to Hélèna Fourment in 1630. A further sign of the personal involvement of the master in the work comes by considering Rubens' personal completion of the canvas, for Rubens was in the habit of entrusting the execution of his works to his studio, on the base of his preparatory designs.

● The work is cited in the antique inventories as *Fashionable Conversation*, since it turned out to be difficult to fix its theme, balanced between allegory and private portraiture. The scions of high society are gathered together in a sumptuous landscape, intent on their diversions and games of love. A velvety sensuality radiates in the atmosphere surrounding the people, finding confirmation in the numerous symbols of love located in the composition. The realistic delineation of the faces, however, brings the allegory back to the concrete world.

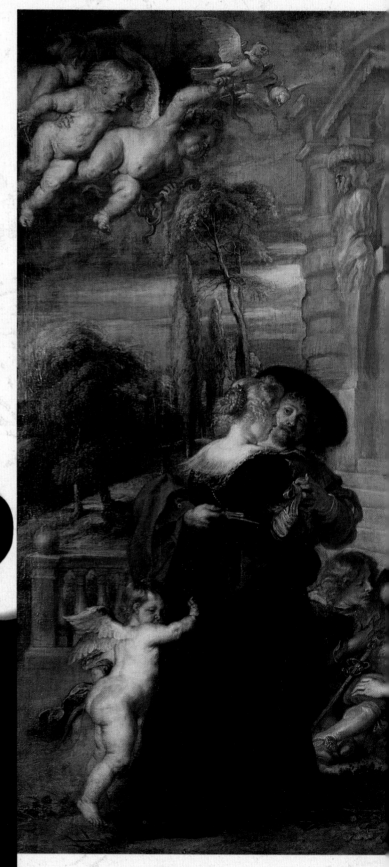

◆ SELF-PORTRAIT
Intense artistic production, and diplomatic activity in the Courts of Europe characterize the life of the artist (Siegen 1577-Antwerp 1640).

● The subject of *The Garden of Love* reconnects to a tradition deeply rooted in Nordic literature, especially medieval. It is a theme particularly in vogue in Renaissance painting, and has illustrious precedent in the countryside concerts of Giorgione and Titian, by whose canvases Rubens was struck during his stay in Venice at the beginning of the century.

● Notwithstanding the apparent timelessness of the subject in which the joys of love come to be immortalized, it is possible to extract precise biographical elements from the image. The portraits of Rubens and his young wife can in fact be recognized in the couple on the left, while their residence is evoked by the architecture and landscape of the background.

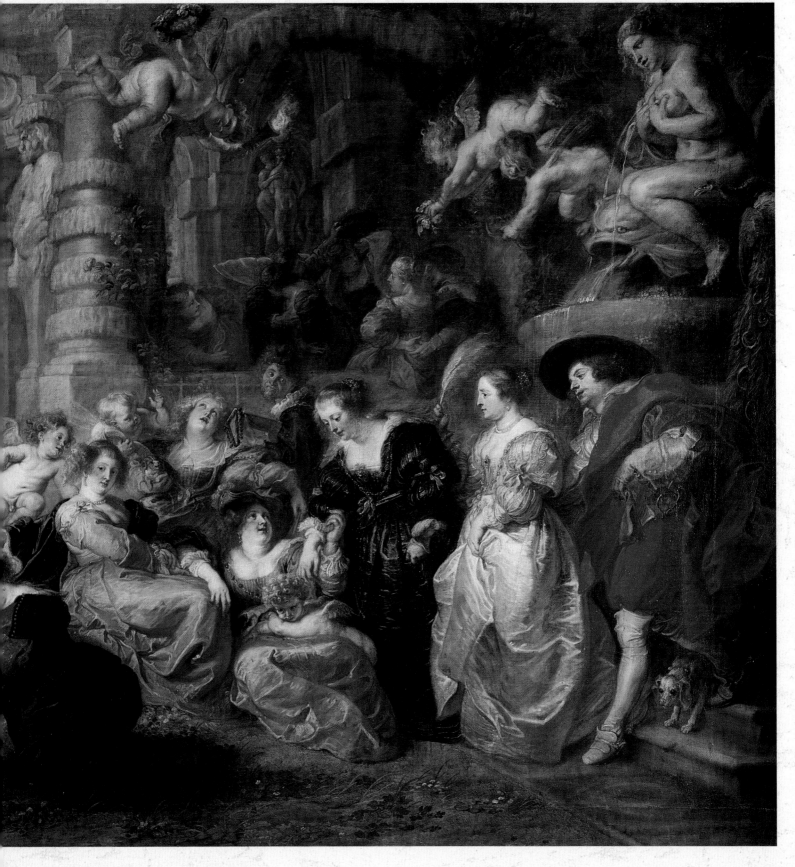

# EXULTATION OF LOVE

The canvas is articulated by numerous episodes and animated by a richness of detail. The meeting of the characters unfolds in a circumscribed environment, limited by the balustrade as if to sanction its elitist nature. The separation of the figures from the nature reflects the tradition of hortus conclusus the space reserved for the Virgin and the saints, which was so sacred that it could not be contaminated by earthly elements.

● The privileged nature of the place, corroborated by the sumptuousness of the clothing, takes on an allegorical value thanks to the affectionate gestures of the figures, the dynamic whirl of the cherubim, and the wealth of symbols that sing the praises of love, especially nuptial. The cherubs, in addition to the arrows with which Cupid inflames the heart, bear the usual attributes of Venus, doves and roses, symbol of beauty and fertility, the dog represents conjugal fidelity.

● The men's and women's faces seem to resemble each other so much as to suggest the presence of only two models, Rubens and his wife Hélèna, confirming, the private character of the painting. The guitar player is conspicuous among the characters for his strongly pronounced and realistic traits. His frowning expression, almost clashing with respect to the environment and the joyous style of the master, is in reality an iconographic citation drawn from the Caravaggesque canvases of the Low Countries. The reference to music reflects a convention as habitual in painting as it is in literature: through musical harmony the affective tuning of a couple is realized.

● The most curious element is determined by the fountain on the right, where the life-size statue of Venus is standing out. As the tutelary deity of encounters of love, Venus is the perfect interpretive key of the picture, and in fact, while her eyes are observing the young people almost as if to exhort them, her gesture discloses an unexpected carnality, which is loaded with allusions to fecundity.

◆ A RECOVERED SERENITY
Rubens portrays himself with his second wife, Hélèna Fourment, at the left of the composition, in an imposing position with respect to the other figures. Left a widow in 1626, the painter took up diplomatic activity to drive away his pain. Coming back to Antwerp in 1630, he married the young woman, who was just 16 years old and came from a middle-class background. Considering his service to the Archdukes, Rubens could have aspired to marry a woman of higher social class, but his goal was also to find a wife who could pose for him without shame. His reconquered serenity poured out in a new artistic creativity, evident in *Portrait with Hélèna Fourment in the Garden of Antwerp* (above, 1631, Munich, Alte Pinakothek).

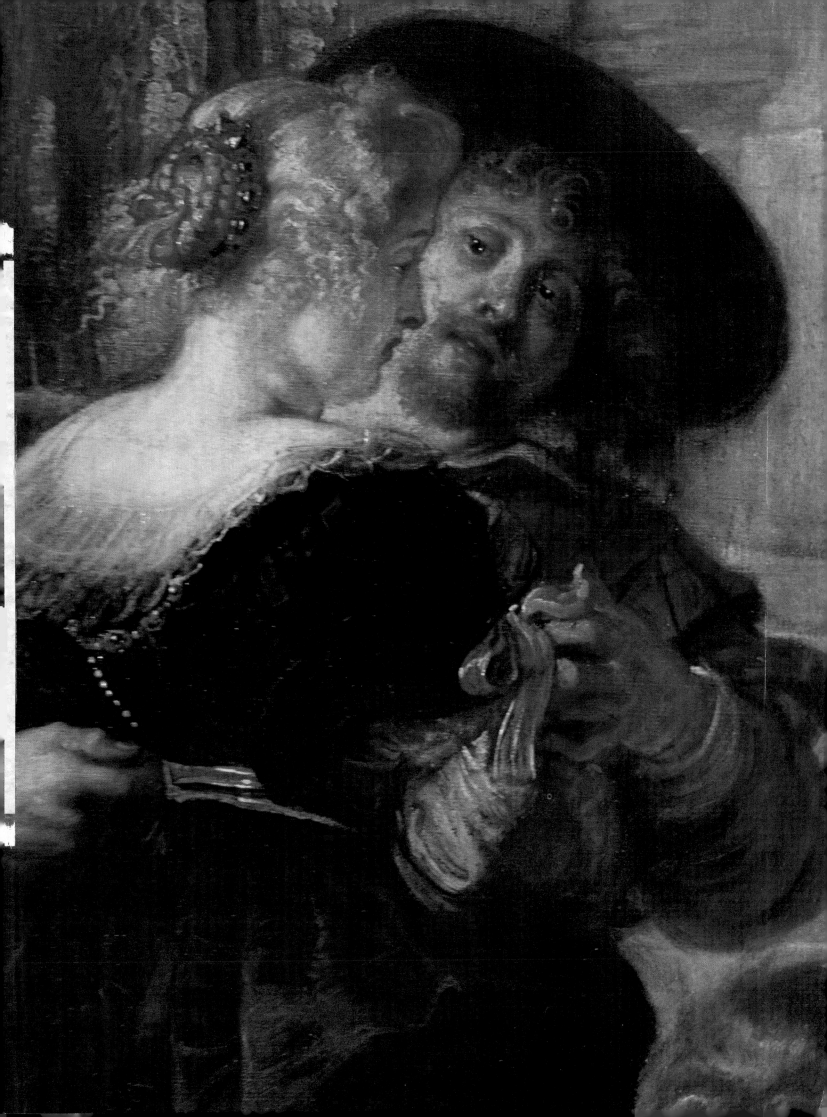

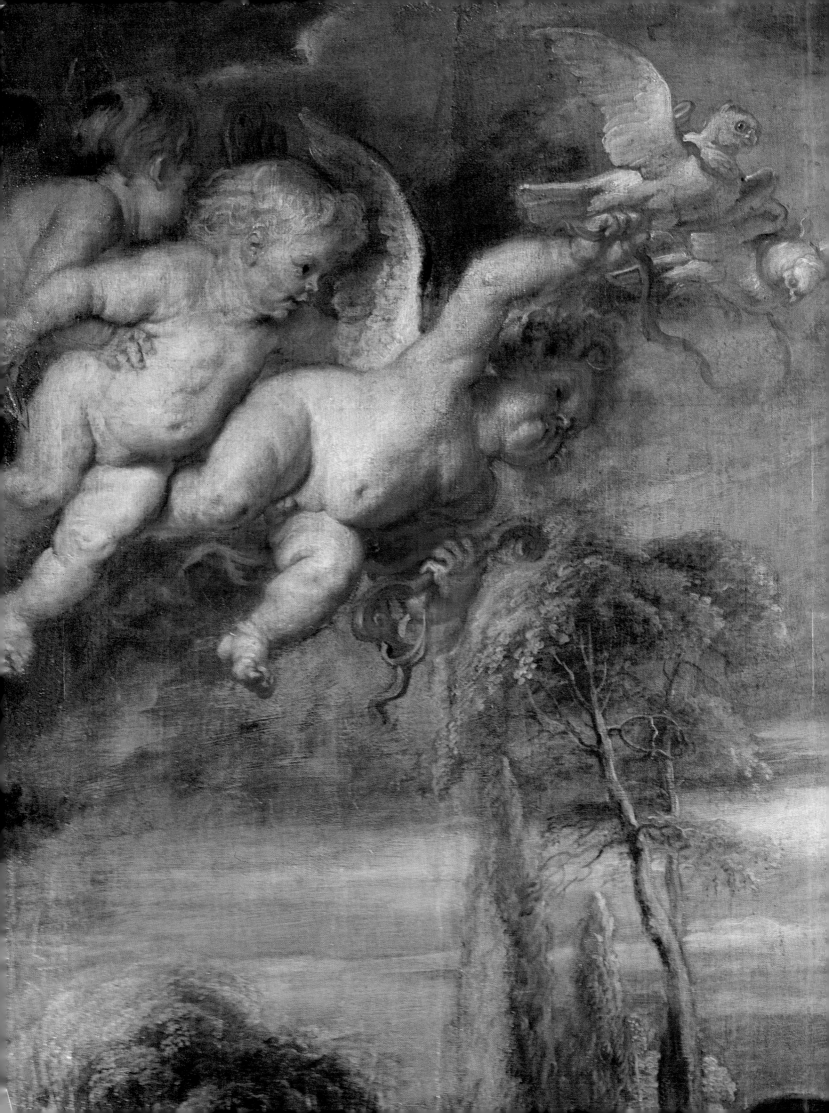

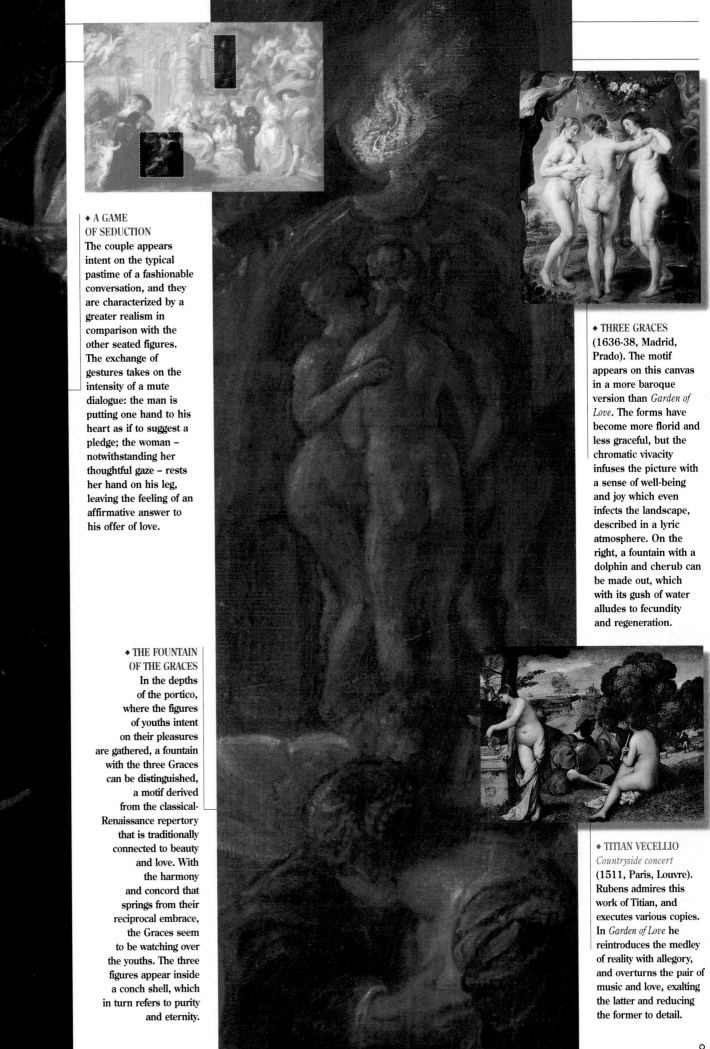

### ◆ A GAME OF SEDUCTION

The couple appears intent on the typical pastime of a fashionable conversation, and they are characterized by a greater realism in comparison with the other seated figures. The exchange of gestures takes on the intensity of a mute dialogue: the man is putting one hand to his heart as if to suggest a pledge; the woman – notwithstanding her thoughtful gaze – rests her hand on his leg, leaving the feeling of an affirmative answer to his offer of love.

### ◆ THE FOUNTAIN OF THE GRACES

In the depths of the portico, where the figures of youths intent on their pleasures are gathered, a fountain with the three Graces can be distinguished, a motif derived from the classical-Renaissance repertory that is traditionally connected to beauty and love. With the harmony and concord that springs from their reciprocal embrace, the Graces seem to be watching over the youths. The three figures appear inside a conch shell, which in turn refers to purity and eternity.

### ◆ THREE GRACES

(1636-38, Madrid, Prado). The motif appears on this canvas in a more baroque version than *Garden of Love*. The forms have become more florid and less graceful, but the chromatic vivacity infuses the picture with a sense of well-being and joy which even infects the landscape, described in a lyric atmosphere. On the right, a fountain with a dolphin and cherub can be made out, which with its gush of water alludes to fecundity and regeneration.

### ◆ TITIAN VECELLIO

*Countryside concert*
(1511, Paris, Louvre). Rubens admires this work of Titian, and executes various copies. In *Garden of Love* he reintroduces the medley of reality with allegory, and overturns the pair of music and love, exalting the latter and reducing the former to detail.

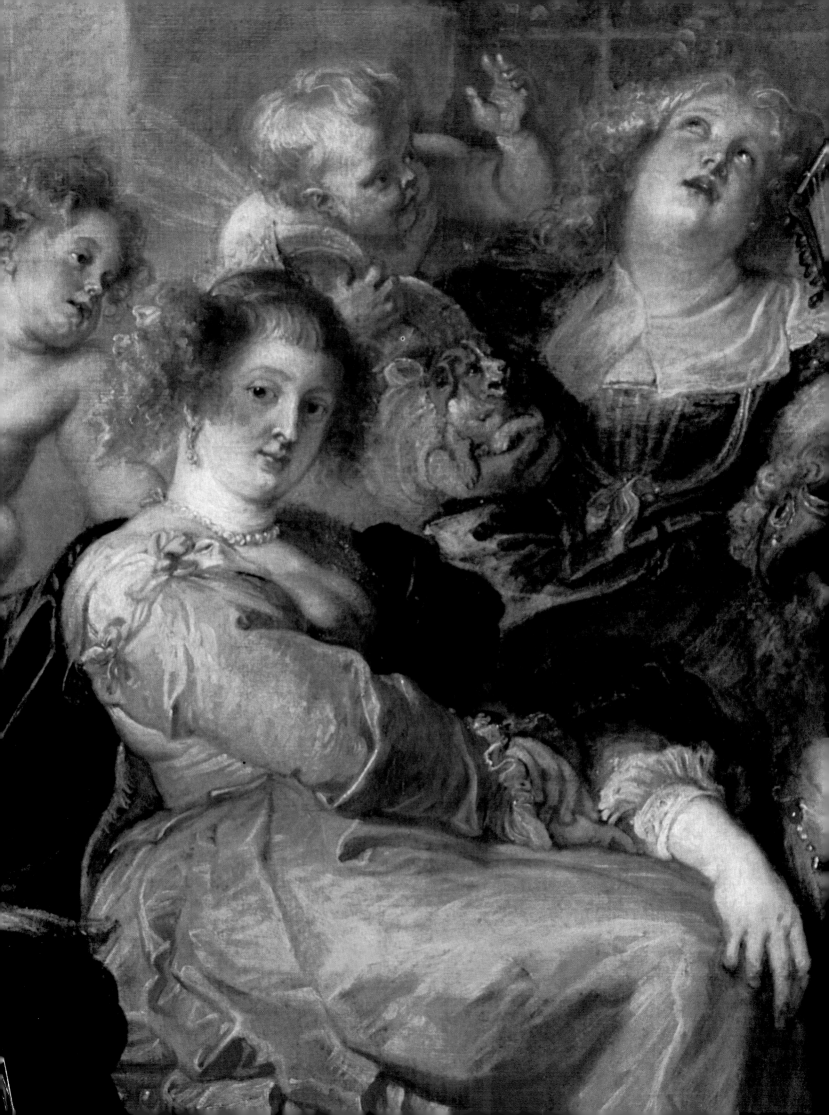

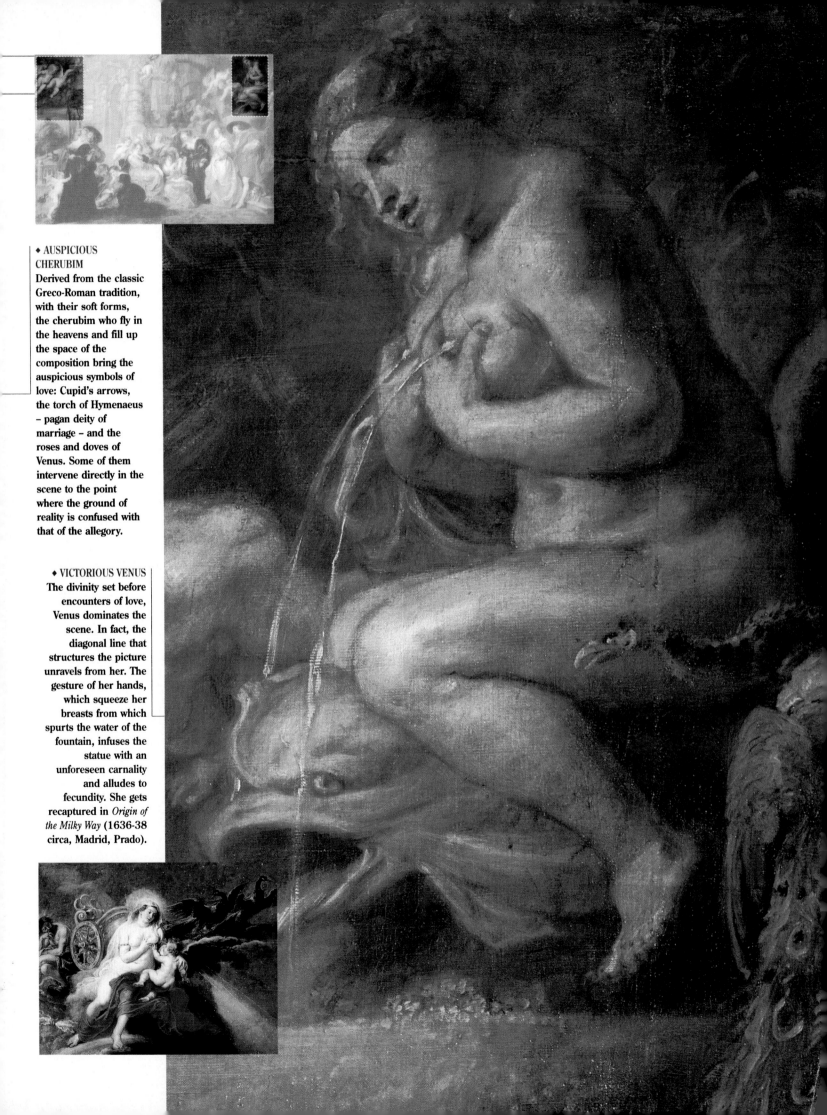

◆ AUSPICIOUS
CHERUBIM
Derived from the classic
Greco-Roman tradition,
with their soft forms,
the cherubim who fly in
the heavens and fill up
the space of the
composition bring the
auspicious symbols of
love: Cupid's arrows,
the torch of Hymenaeus
– pagan deity of
marriage – and the
roses and doves of
Venus. Some of them
intervene directly in the
scene to the point
where the ground of
reality is confused with
that of the allegory.

◆ VICTORIOUS VENUS
The divinity set before
encounters of love,
Venus dominates the
scene. In fact, the
diagonal line that
structures the picture
unravels from her. The
gesture of her hands,
which squeeze her
breasts from which
spurts the water of the
fountain, infuses the
statue with an
unforeseen carnality
and alludes to
fecundity. She gets
recaptured in *Origin of
the Milky Way* (1636-38
circa, Madrid, Prado).

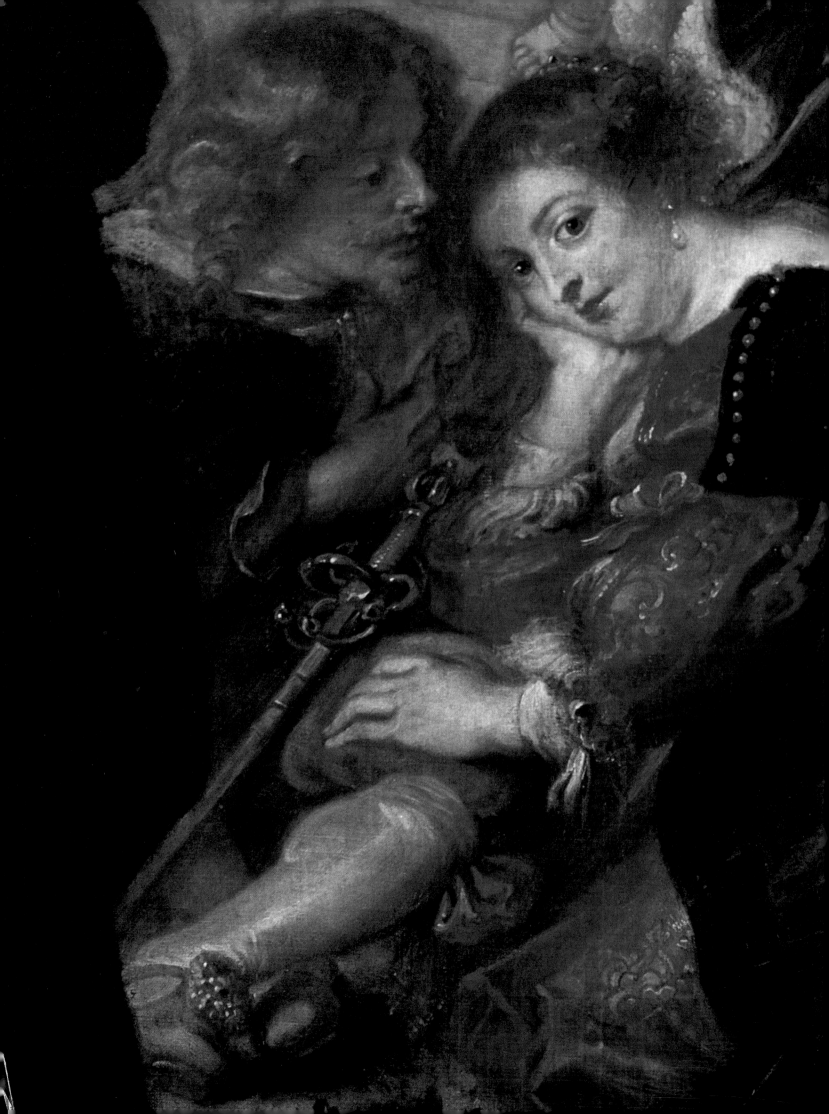

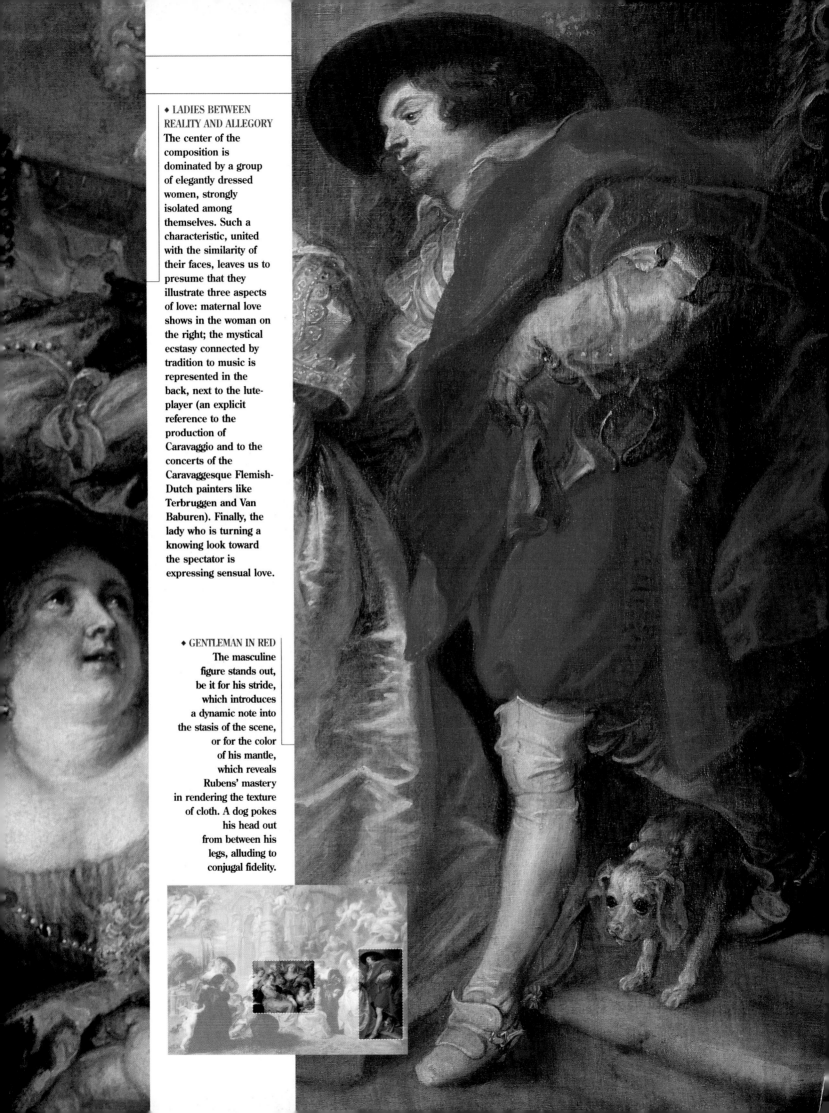

◆ LADIES BETWEEN
REALITY AND ALLEGORY
The center of the
composition is
dominated by a group
of elegantly dressed
women, strongly
isolated among
themselves. Such a
characteristic, united
with the similarity of
their faces, leaves us to
presume that they
illustrate three aspects
of love: maternal love
shows in the woman on
the right; the mystical
ecstasy connected by
tradition to music is
represented in the
back, next to the lute-
player (an explicit
reference to the
production of
Caravaggio and to the
concerts of the
Caravaggesque Flemish-
Dutch painters like
Terbruggen and Van
Baburen). Finally, the
lady who is turning a
knowing look toward
the spectator is
expressing sensual love.

◆ GENTLEMAN IN RED
The masculine
figure stands out,
be it for his stride,
which introduces
a dynamic note into
the stasis of the scene,
or for the color
of his mantle,
which reveals
Rubens' mastery
in rendering the texture
of cloth. A dog pokes
his head out
from between his
legs, alluding to
conjugal fidelity.

# COQUETRY REDISCOVERED

The games of love presented in *Garden of Love* reveal a society quite far from the rigid ceremony of the Spanish Court, and instead, sustained by a great freedom of action. The painting, to all appearances suspended in a timeless atmosphere, reflects a changed historical situation: while Spain is heading towards decline, the Low Countries are temporarily recovering their independence, letting themselves be attracted by France, sensitive above all to their worldly customs.

● The austerity of Spanish etiquette thus opposes the new model of French behavior, which with the example of Queen Maria de' Medici entrusts to women a more uninhibited and active role in the life of the society. To the dark tones and fixedness that had characterized the pictures inspired by the style and fashion of the Castilian reign of the sixteenth century, now respond a chromatic explosion and a new visual seduction.

● The brilliantly colored tones, the research into hairstyles and above all, the sumptuousness of the clothing, infuse *The Garden of Love* with an explicitly hedonistic connotation, and invite the appreciation of feminine beauty. Sober and often idealized elegance, typical of the Renaissance, here gives way to a pleasant lingering on soft, rounded forms, evidenced by the generous necklines of the dresses. A new aesthetic canon thus imposes itself in painting: to the rather excessive rigor with which the Spanish style had covered the body, is now substituted a French style which is not afraid to put feminine graces on display, liberating the neckline to allow the breasts to be intuited.

● Alongside the feminine model imported from France, Rubens, in the last phase of his production, proposes a conception of feminine charms based on buxom forms. His figures offer themselves to the viewer in all their abundance and with a more spontaneous capacity for gesticulation. Their naturalism shuns any ideal archetype, to catch the woman in her physical, and thus existential reality. This rediscovery of a woman's carnality and of her sensual charge, which characterizes Rubens' more mature work, has often prejudiced his fame through the centuries, however, especially in the ages in which classical aesthetics prescribed graceful and almost fragile forms in the portrayal of women.

◆ LADY OF THE LICNIDI (1602, Verona, Castelvecchio Museum). The portrait belongs to Rubens' early production, and goes back to his stay in Italy. The unidentified lady, is described with a black dress and huge ruff typical of the Spanish fashion of that age. The skill of his brushwork stands out in the over-refinement of the ruff, and exalts the face with respect to the dark and anonymous background. In successive portraits Rubens will open the background with landscapes or details that animate the picture and reduce its fixedness.

◆ THE LADY IN BLUE The figure stands out for the brilliant and cold tone of the dress, brought near the warm tones of the white and yellow. Her hairstyle tries to leave open her forehead and decolletage. Precious hairclips adorn her head, which pick up the rhythm of the pearl earrings. The eye is captured by the deep neckline, which reveals a femininity recovered from French fashion. Rubens renounces the austerity of Spanish dress and dominant black, which make the faces heavier and almost age them. The features of the face and blond head of hair are those of his wife Hélèna, the main model for the composition.

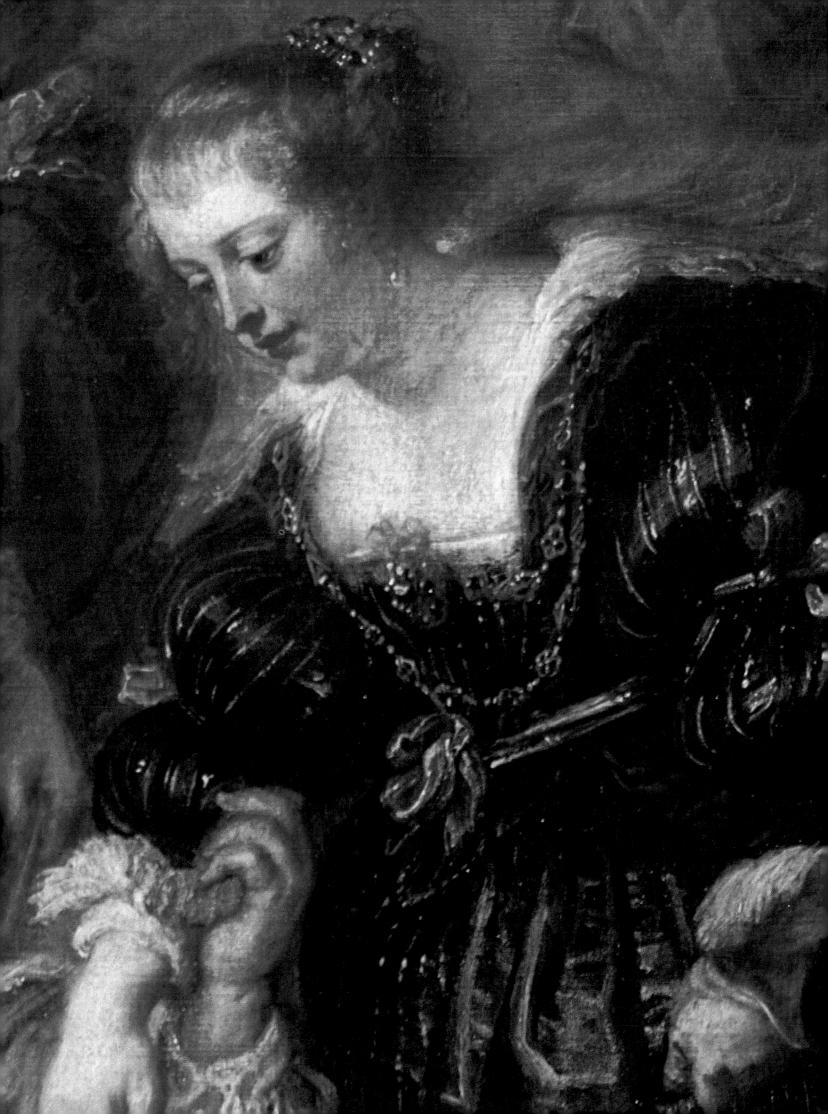

◆ SUZANNE FOURMENT (1622 ca., London, National Gallery, detail). The woman portrayed is the sister of Hélèna Fourment, Rubens' young wife. Vivacious and joyous colors dominate the canvas, which underlines the sensuality of the neckline, again of French derivation. The face and chest have a pearly transparency which responds to the dark tonality of the hat and corset, but also to thicken the clouds in the background. The image is entirely entrusted to color, as Rubens did not resort to a drawing in order to structure it. The painting – a hymn to beauty and youth – recalls the latest work of Titian in the pictorial draft.

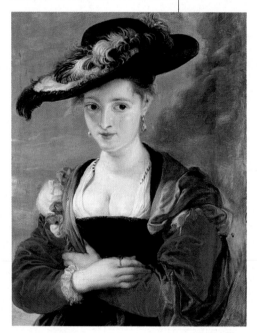

◆ THE LADY IN WHITE The figure in profile stands out for its elegance of dress and jewels, but also for its position. In fact, it is placed, with its white dress, between the lady in blue and the man with the red mantle, and thus comes to be exalted through its contrast with the primary colors. For a play of destiny, the drawing near of the three colors gives *ante tempora* life to the tri-color, which, beginning with the Revolution of 1789, will characterize the flag of France. The florid and sensual appearance of the woman is reanimated by the dominant white of the dress, by the delicate carnality, and by recourse to the pearls of the necklace and earrings, symbol of purity.

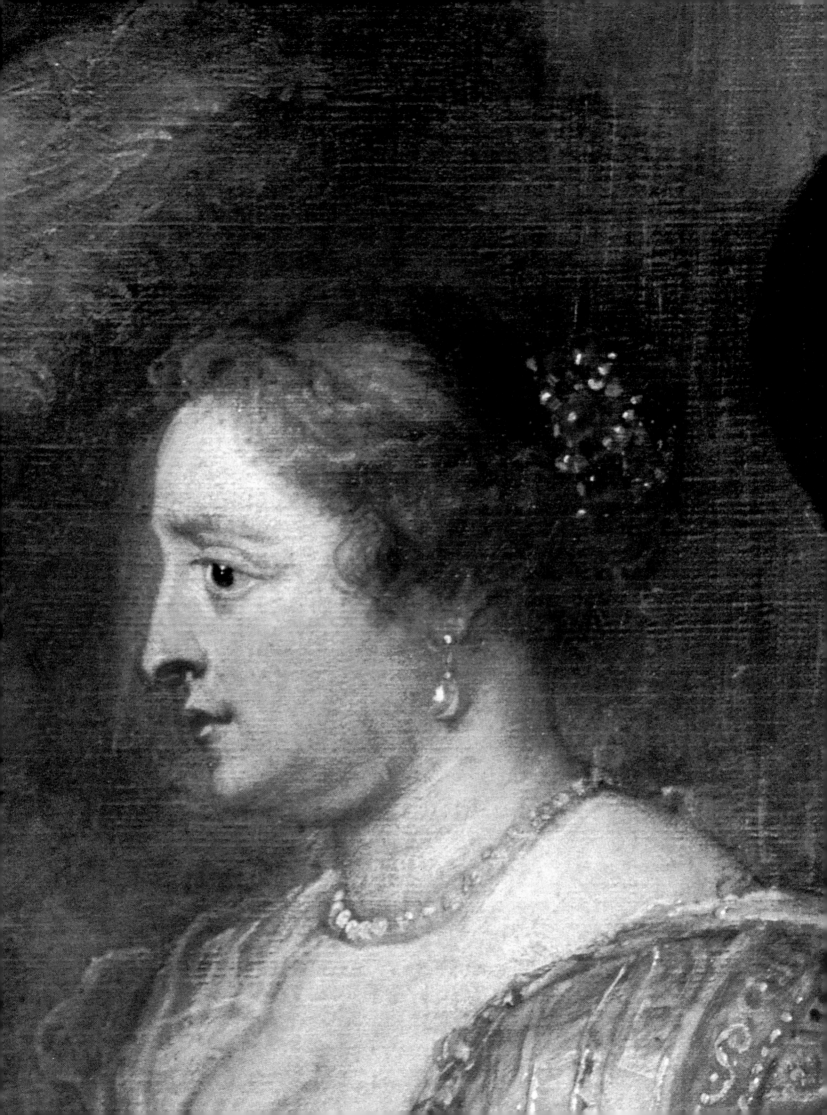

# AN ITALIAN STYLE GARDEN

Rubens painted *The Garden of Love* in Steen Castle, where he moved after having abandoned the city of Antwerp. Here, he sees to the decoration of the park with statues, fountains, grottos and porticos, according to a custom particularly in vogue in the seventeenth century, when these represent status symbol. During his stay in Italy, the master has the chance to see the sixteenth century villas and palaces of Genoa (on which he publishes a text in 1622). Remaining conquered by their charm, he decides to have a residence and garden built which recaptures their style. And so it is that, for the architectural setting of *The Garden of Love*, he inserts the portal to his estate: the imposing columns and caryatids which support the gable reflect a sixteenth century model typical of Venice.

◆ THE VILLA OF STEEN Rubens acquires an estate in Antwerp in 1610, and has a monumental portico built there (below), with a sumptuous style. From this residence, (today site of the Rubens Museum), the painter gets hints for the setting of *The Garden of Love* (at right, in a detail). Recapturing the gable with the great conch, which evokes eternity, infuses grandeur to the composition. The foreshortening of airy landscape (at left) underlines the pleasant setting of the scene.

● At Steen, Rubens concentrates on the production of landscapes, a genre that he has neglected until this time. This infuses a breath of air to his canvases, given that the presence of natural elements spreads out toward the horizon, suggesting the sense of its vastness. All the same, the nature that he portrays remains domestic, never wild, always ending up being controlled by man. It is not by chance that in the canvas of Prado the landscape remains a mere element sent to the border.

● With respect to the traditional type of painting, which sets motionless figures in a static environment, Rubens introduces a freshness and spontaneity through which his characters integrate themselves gradually into the space. So, recovering aerial perspective from Leonardo, and with a by now quite strong brushwork, intentionally recalling the latest work of Titian, he seems to set his figures in a vibrant atmosphere.

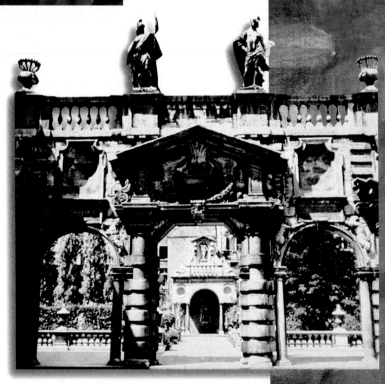

# A DIPLOMATIC PAINTER

Rubens' education, before being artistic, is literary. The painter is trained on the humanistic texts, and the teaching of this culture informs not only his pictorial work, but his entire life. With the insatiable desire to resemble his models, he re-elaborates in an original way the countless sources that he has come into contact with, in polyhedric activity. He is a collector of antiques, passionate reader of the Greek and Latin classics, and diplomat for important families of the age. Counselor and courtier, he is the owner of a Florentine studio that numbers some of the most famous painters of the genre. Finally, he is a writer, and in addition to the treatise on sculpture *De imitatione statuarum*, he even writes *Palaces of Genoa* in fluent Italian.

● The anecdotes of his students are of note, according to which Rubens, while waiting for the completion of a painting, pursues various activities at the same time: receiving guests, listening to the reading of literary texts, dictating letters, and planning trips.

● The most singular element of his personality is his diplomatic sense. Called to Mantova by Vincenzo Gonzaga, who doesn't have enough funds to commission works to him with regularity, he profits from it by traveling. As his ambassador he goes to Spain where he visits the monastery of Escorial with Velasquez. Re-entering Antwerp, he becomes the painter of the Archdukes Alberto and Isabella, for whom he goes to London and Madrid, to copy works of art, but also to conclude political accords. In 1629 he concludes a peace treaty with England for which he receives an honorary degree in London.

● The last part of his life, even though gladdened by a peaceful marriage and by various honorific recognitions, such as the title of knight, is plagued by gout, which progressively strikes his hands and prevents him from painting.

◆ CARAVAGGIO
*The Death of the Virgin*
(1605-06, Paris, Louvre). The work, refused by the clients at Santa Maria della Scala for its crude realism, is bought by Gonzaga, upon the advice of Rubens.

◆ THE TRINITY, WORSHIPPED BY THE GONZAGA FAMILY (1604-06 ca., Mantova, Ducal Palace, reconstruction). The canvas, in part destroyed, was done for the church of the Jesuits of the Most Holy Trinity of Mantova.

◆ PORTRAIT OF MARIA DE' MEDICI PRESENTED TO HENRY IV (1622-23, Paris, Louvre, reconstruction). The painting refers to the wedding by proxy of the king of France with the noblewoman. Rubens was present at the event.

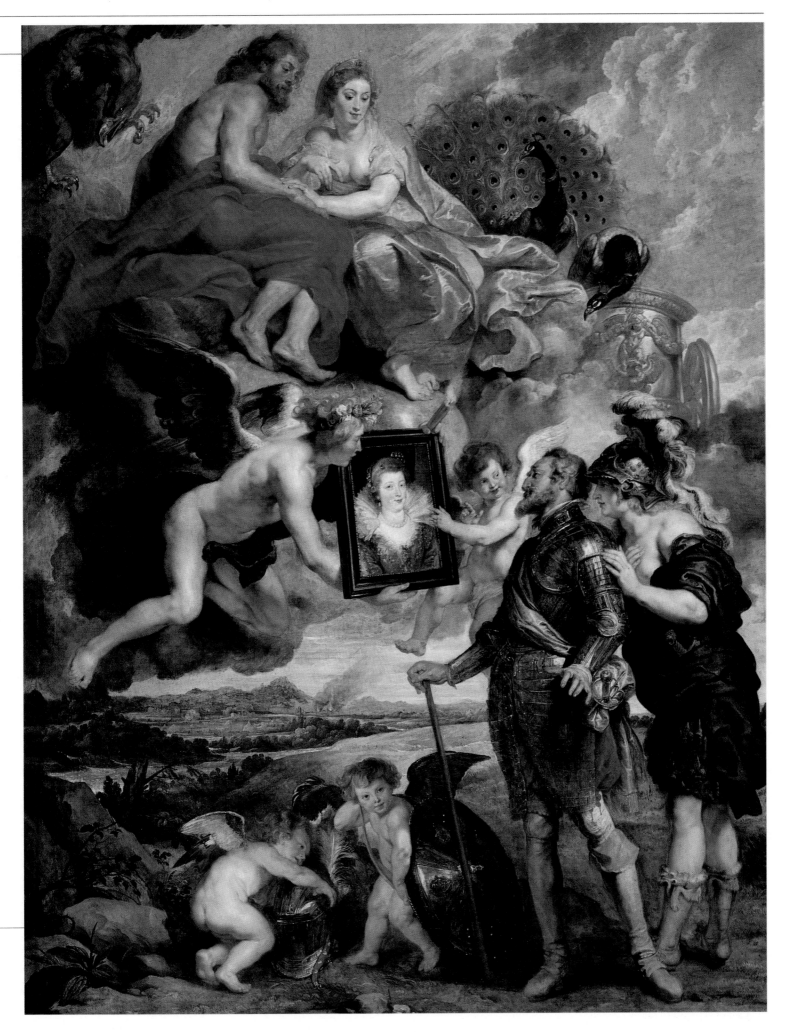

# THE LESSON OF THE CLASSICS

When Rubens reaches Italy in 1600, he leaves behind him not only an apprenticeship of five years, but also his first studio. In Antwerp, three masters have shaped his artistic growth. From Veraecht (1561-1631), the painter has learned a precise and refined technique, but also a taste for Italian-style landscapes with ruins. Van Noort (1520-1570) has shown him, instead,

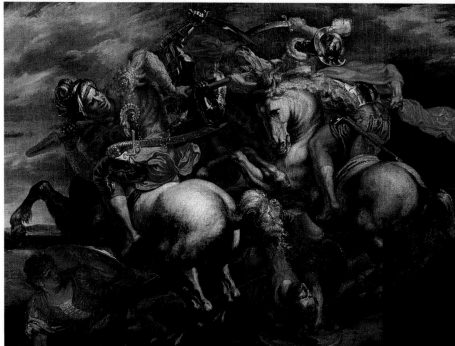

the priority of painting figures over landscapes, and has thus started him on his way to distinguish genres. Otto Vaenius (1556-1629), a rather well-known artist, who spent much time in Rome and Parma, has convinced him instead of the necessity of a trip to Italy to complete his education.

● In Venice he meets the Duke of Mantova, Vincenzo Gonzaga, who takes him into his service. Rubens paints commemorative portraits for him, not to mention various copies of masters like Michelangelo and Titian, and antique statuary. But above all, he begins a diplomatic career, and one as advisor in the purchasing of works of art. In his stay he can travel with regularity, and deepen his knowledge of Italian art. For his Flemish training, he remains struck above all by the warm tonalism of Titian and the luminous contrasts of Caravaggio.

● In Rome, where he also resides with some breaks until his departure in 1608, he leaves three pictorial cycles which testify how he re-elaborated the Italian models and gradually developed an autonomous style. In fact, he paints an *Adoration of the Shepherds* (to-

day at Fermo, Italy), the altarpiece for the Oratorian church of Santa Maria of the Vallicella (of which the first version was refused), and three canvases for the chapel of Santa Elena of the Holy Cross of Jerusalem, only one of which has survived.

● His abrupt return to Antwerp, in 1608, causes Rubens to have to re-elaborate autonomously, far from the influence of the originals, the countless suggestions derived from the works that he has copied. Meanwhile, the paintings that he has left behind in Rome constitute the germ of baroque art, and are the foundation for the formation of Gian Lorenzo Bernini and Pietro da Cortona. According to various studies, in is in fact not possible to explain otherwise the Venetian type of tonal direction conspicuously present in Roman painting of the seventeenth century.

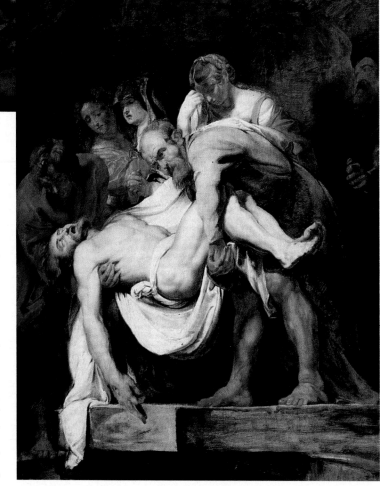

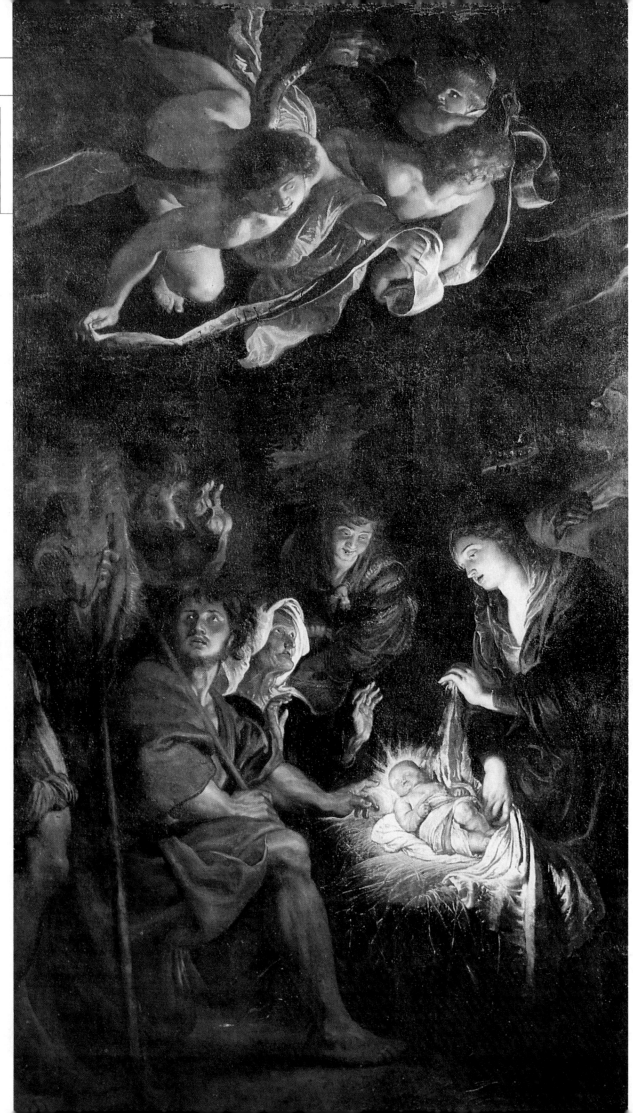

◆ ADORATION OF THE
SHEPHERDS
(1608, Fermo, Italy,
Civic Picture Gallery).
Rubens painted this
*Adoration* for the
Oratorians, for whom
he also painted the
altarpiece of Santa
Maria of the Vallicella.
The divine light which
explodes from the
darkness is a tribute to
Correggio.

◆ THE BATTLE
FOR THE STANDARD
(1605 ca., Vienna,
Gemäldegalerie
der Akademie
der Bildenden Künste).
The canvas recaptures
*The Battle of Anghiari*
of Leonardo, of which
Rubens also did a
drawing. The fulcrum
of the scene is the
tormented movement
of the figures.

◆ DESCENT FROM
THE CROSS
(1611-12, Ottawa,
National Gallery).
In Italy, Rubens copies
the works of the most
famous and affirmed
masters, but is also
one of the first
to understand the
dramatic power of
Caravaggio. Fascinated
by his *Deposizione*
(above ,1602-04,
Rome, Vatican Picture
Gallery), while at Santa
Maria of the Vallicella,
the painter paints a
copy of it in which he
deepens the tragic
expression of the
figures, and suggests an
apse in the background.

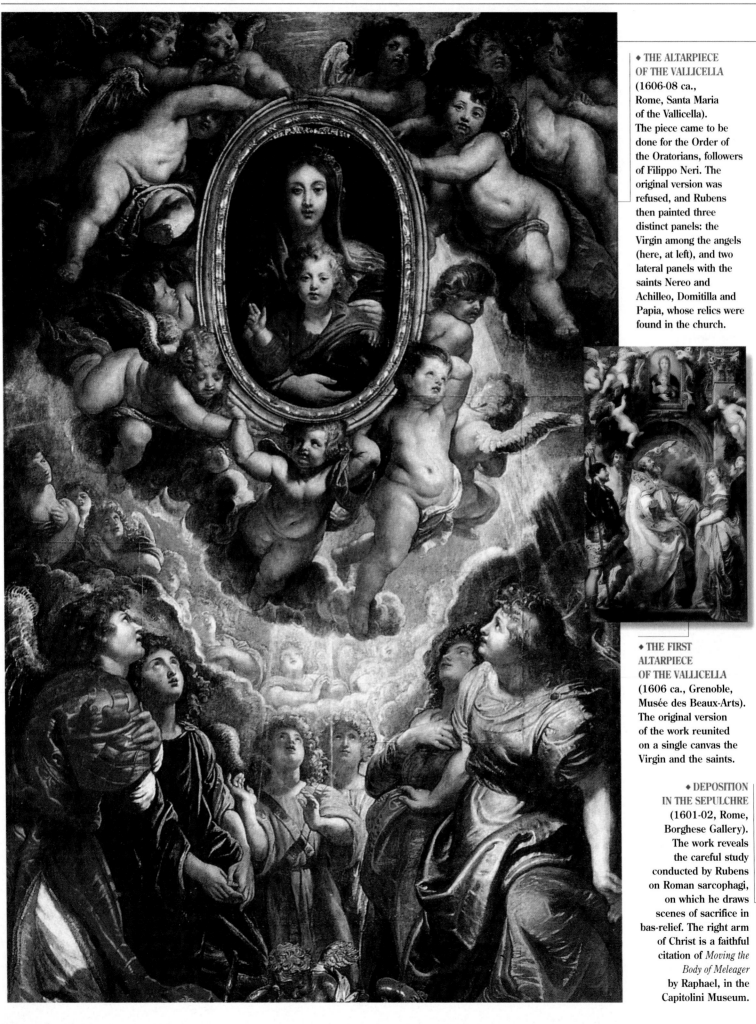

◆ THE ALTARPIECE
OF THE VALLICELLA
(1606-08 ca.,
Rome, Santa Maria
of the Vallicella).
The piece came to be
done for the Order of
the Oratorians, followers
of Filippo Neri. The
original version was
refused, and Rubens
then painted three
distinct panels: the
Virgin among the angels
(here, at left), and two
lateral panels with the
saints Nereo and
Achilleo, Domitilla and
Papia, whose relics were
found in the church.

◆ THE FIRST
ALTARPIECE
OF THE VALLICELLA
(1606 ca., Grenoble,
Musée des Beaux-Arts).
The original version
of the work reunited
on a single canvas the
Virgin and the saints.

◆ DEPOSITION
IN THE SEPULCHRE
(1601-02, Rome,
Borghese Gallery).
The work reveals
the careful study
conducted by Rubens
on Roman sarcophagi,
on which he draws
scenes of sacrifice in
bas-relief. The right arm
of Christ is a faithful
citation of *Moving the
Body of Meleager*
by Raphael, in the
Capitolini Museum.

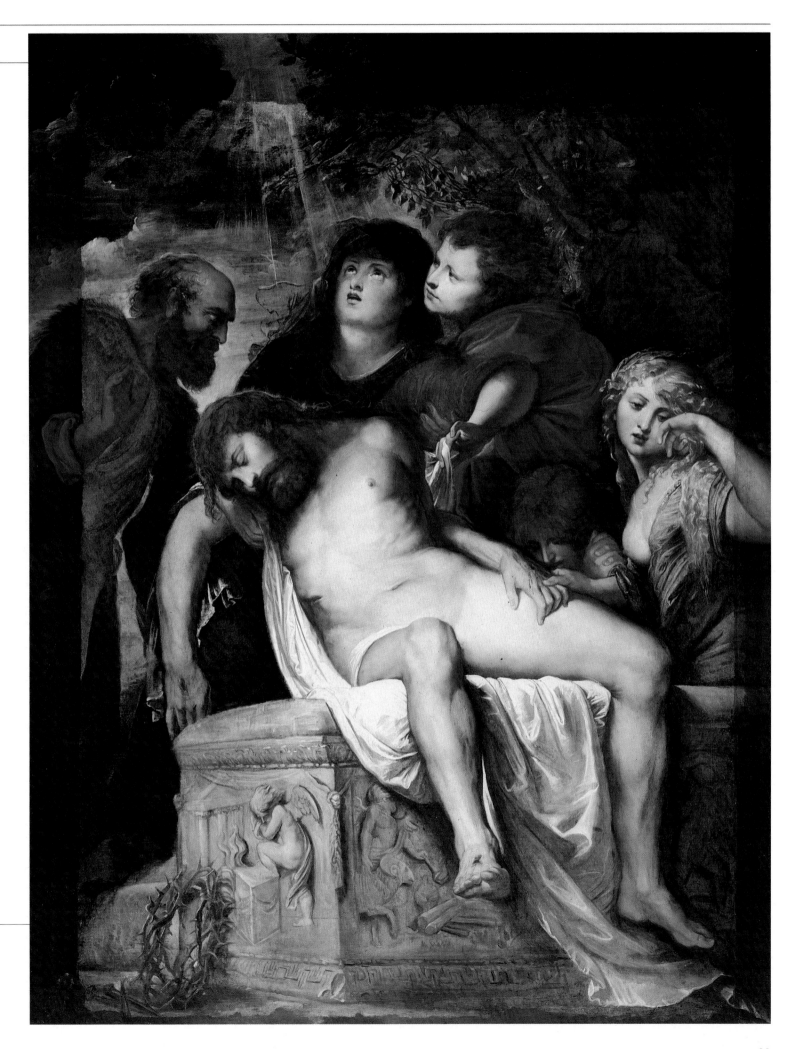

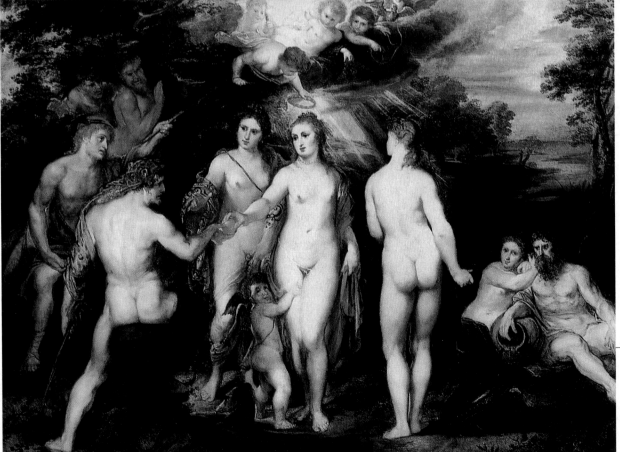

◆ THE APOTHEOSIS
OF JAMES I
(1633-34,
London, Whitehall,
Banqueting House).
The work is part
of the decorative cycle
realized for the banquet
hall of the palace at
Whitehall. It was done
for Charles I of the
Stuarts, whom Rubens
had come to know in
Paris. The canvas,
executed in Antwerp,
is principally owed to
the pupils of the studio.

◆ CORREGGIO
*Vision of Saint John
at Patmos*
(1520-23, Parma,
Italy, San Giovanni
Evangelista). Rubens
remains fascinated
by the virtuosity
of Correggio and his
figures, caught in a
dizzy foreshortening.
The luminosity that the
Venetian painter
achieves with light
colors also strikes him.
In the spiral dynamism
and foreshortened
perspective of his
*Apotheosis of James I*, he
celebrates the memory
of the cupola of Parma.

◆ THE JUDGMENT
OF PARIS
(1600-01, London,
National Gallery).
This canvas of a profane
subject was perhaps
commissioned by
Vincenzo Gonzaga.
Suggestions of sixteenth
century Venetian
painting are evident in
the luministic rendering,
above all Tintoretto and
Titian. Meanwhile Paris,
described from behind
with a vigorous
plasticity, takes his cue
from *Vocation of Saint
Matthew* by Caravaggio.

# THE ALTARPIECE

Upon his return from Italy, Rubens found Antwerp in recovery, after the destructions of the Protestant Iconoclasm and the encounters with Spain. In spite of having ceded commercial supremacy to Amsterdam, for a painter of this age the city presents itself as an alluring center.

● Rubens, who has already since 1598 been a member of the Guild of San Luca, the brotherhood in which artists gather together, obtains, thanks to his friends, the first sacred commissions, and in 1609 he becomes Court Painter in the service of the Archdukes Alberto and Isabella.

● After being confronted with Roman Orthodoxy in Italy, he becomes an interpreter of the renewed Catholic faith. Beyond canvases of a private nature, he realizes a *Raising of the Cross* for the church of Santa Valpurga, and a *Descent from the Cross* for the Antwerp cathedral. This early work smacks of Italian suggestions: the bodies demonstrate a tormented plasticity reminiscent of Michelangelo, with contrasting light and color in the style of Car-

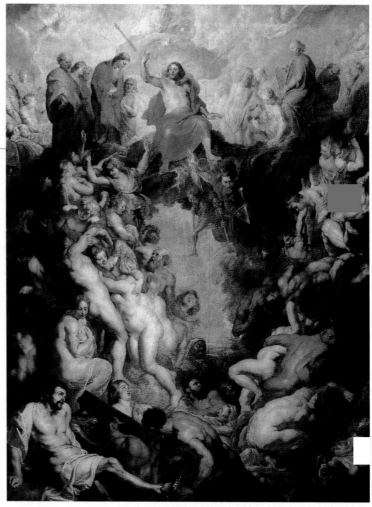

♦ UNIVERSAL JUDGMENT (1615-16, Munich, Neue Pinakothek). The canvas, more than six meters (20 feet) tall, is done for the Jesuits, and resounds with the example of Michelangelo. It comes to be rejected for its nudes.

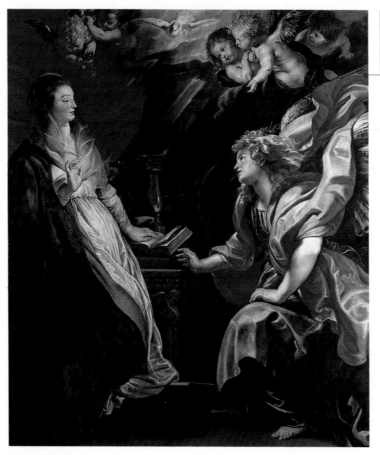

♦ ANNUNCIATION (1609-10, Vienna, Kunsthistorisches Museum). The figures are presented without distinction between celestial and earthly space, as in the Renaissance tradition.

avaggio. The grandness of the canvases and forms rather evokes Tintoretto.

● Ruben's baroque style explodes in *Universal Judgment* of 1615, in *The Miracles of Saint Ignatius of Loyola* of 1618, and in the 1620 cycle for the ceiling of the Jesuit church of Antwerp (destroyed by a fire). In these figure compositions, the forms are softened, the colors become more brilliant, and the faces of the women begin to take on the characteristics typical of the artist. In the sketches for the ceiling decoration for the Jesuits, alongside his virtuosity of invention, the artist reveals a deepened understanding of optical laws.

● In 1618, following the outbreak of the Thirty Years War, the number of religious commissions drops off, and Rubens turns himself principally to commissions of a profane or commemorative nature, for the sake of the royal families of France and England, and for the Archdukes of the city of Antwerp.

♦ THE RAISING OF THE CROSS (1610, Antwerp, Cathedral). The work, with a rough plasticity typical of Michelangelo, is part of a triptych for the Church of Valpurga, later transferred to the cathedral of the city.

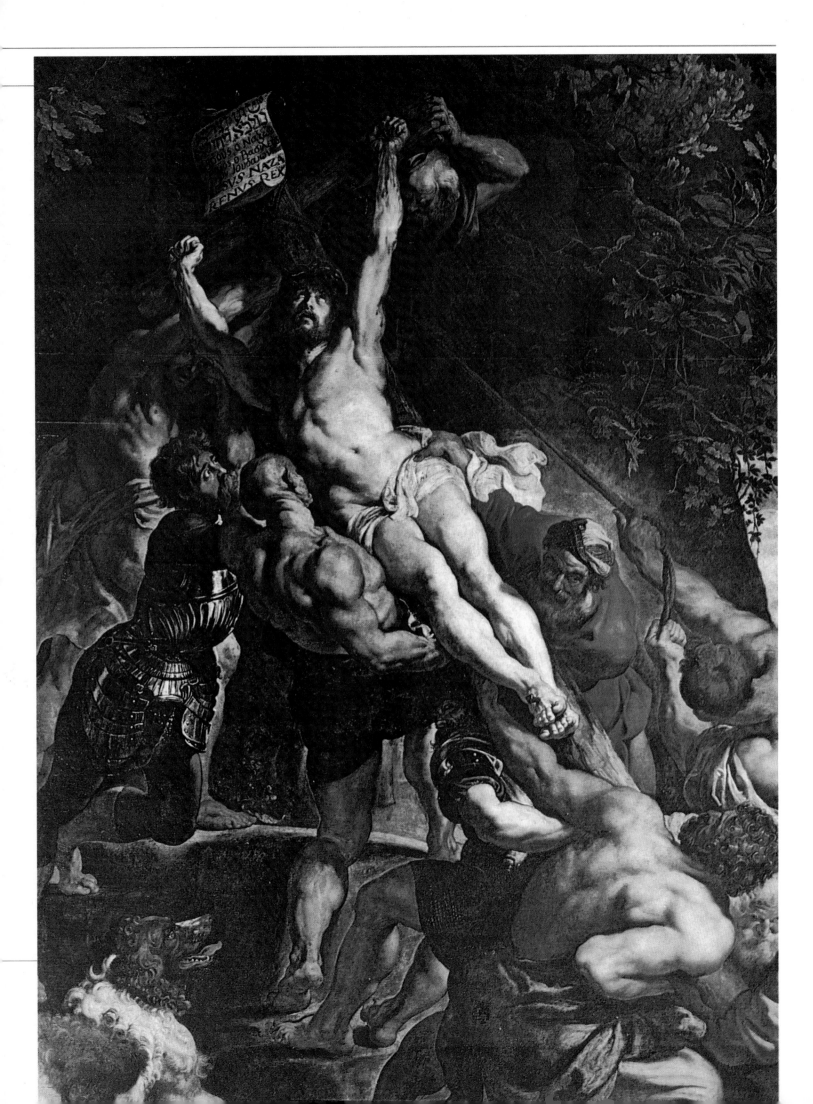

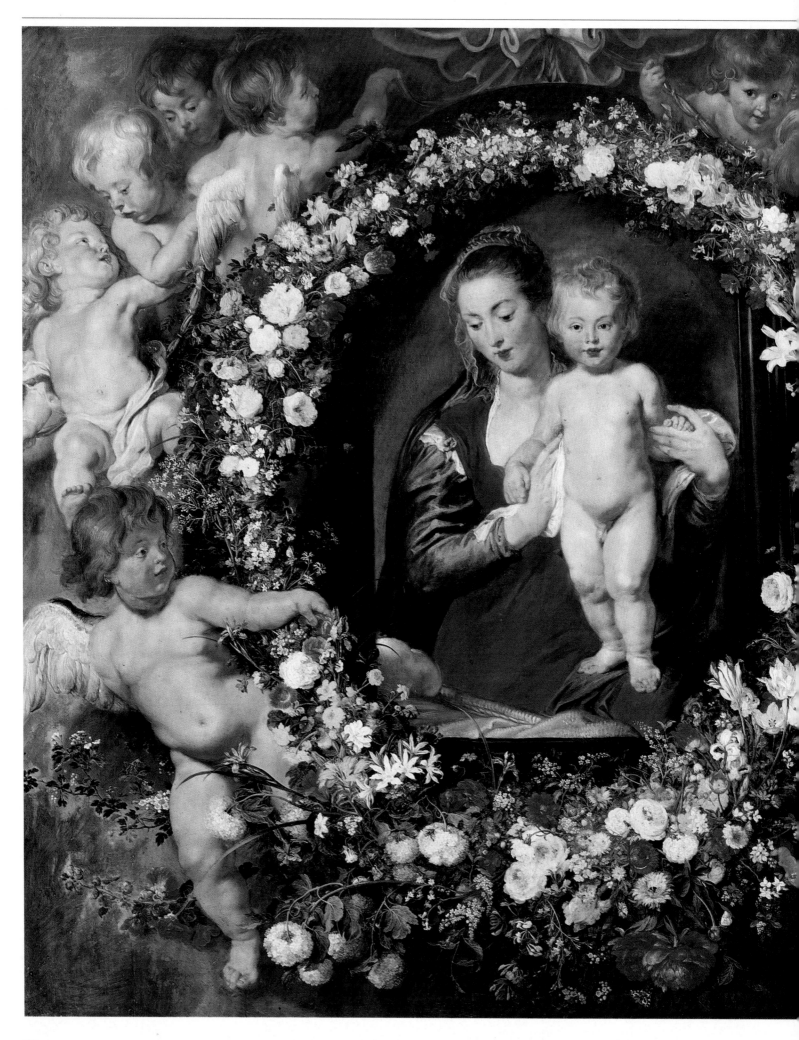

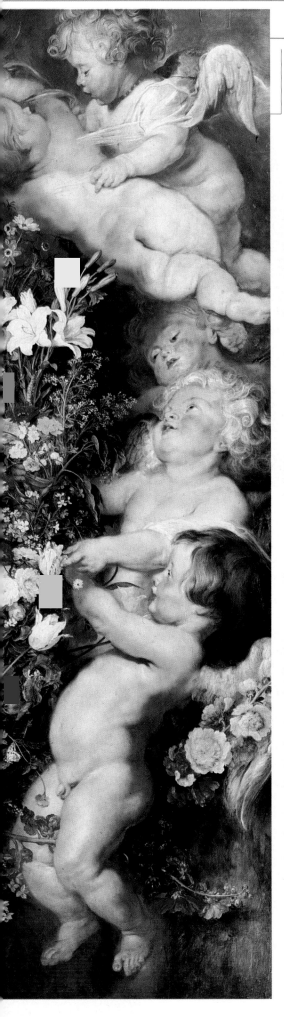

◆ MADONNA
IN A GARLAND
OF FLOWERS
(1620 ca., Munich,
Alte Pinakothek).
The painting,
of small dimensions
and private destination,
is done by Rubens
with Jan Bruegel
of Velluti,
(1568-1625),
who was entrusted
with the work of the
garland of flowers,
a jewel of technical
virtuosity and vivacity
of color. The Madonna
is an ideal figure,
but Ruben's son
Albert is recognizable
in the Child.
The eleven cherubs
which surround
the garland represent
the apostles, without
the traitor Judas.

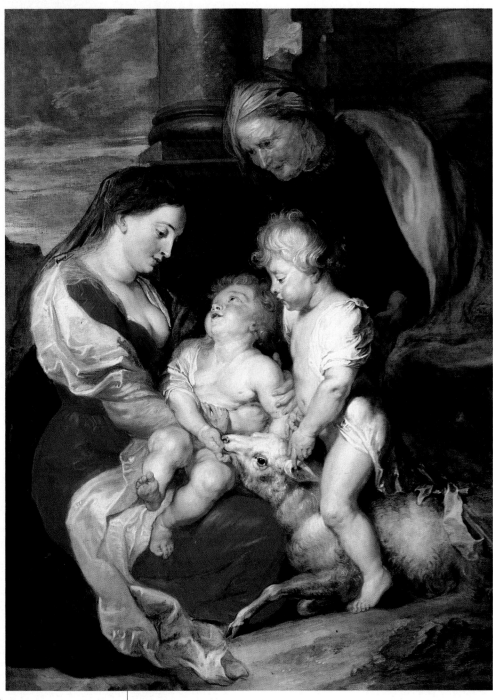

◆ THE HOLY FAMILY
WITH THE LAMB
(1614-15, Lugano,
Thyssen-Bornemisza
Collection).
Perhaps one
of the most famous
canvases of the genre
painted by Rubens,
the work reflects
the happiness
of the painter, above
all in his profane
pictures. In the serenity
of the familial scene,
an unexpected point,
and judged
embarassing, is the
uncovered breast of the
Virgin. The expressive
power of the color gives
life and solidity to the
forms, and exalts the
grace of the subject.

# PROFANE SUBJECTS

The singularity of Rubens' work lies in twofold spirit, sacred and profane. In fact, he recognizes the authority of the sovereign and that of the Church as part of a single worldview. Faithful to the proper educative responsibilities of the art of the Counter-Reformation, and careful to avoid the excesses of its stylistic exuberance, he shows his versatility in the realization of sensual works of mythological subjects.

● The profane type of production, which starting with the second decade of the seventeenth century even includes sketches for tapestries, presents for the pleasure of the client those classical myths which Rubens knows so well, due to his scholarly culture. The more limited dimensions of these canvases destined for private use, and the greater thematic freedom proper to these subjects, permit him to vent his creative impulse in all its richness. But, independently of the subject in question, his goal is to arouse emotions through the use of warm coloring, soaked in light, applied to soft forms that are intentionally alluring.

● Far from the restrictions of the common sense of modesty and that of religious rigor, the master can uncover the bodies and play with a veiled eroticism, as with a luxuriant nature which offers itself to man. Moreover, works like *Prometheus* and *The Education of Maria de'Medici* reflect his custom to work with pupils specialized in the execution of details, such as animals and still life.

● In his profane production, Rubens flatters his clients – the Archdukes Alberto and Isabella as with the Queen of France Maria de'Medici or local sponsors – with learned quotations, and invites them to recognize the hidden pattern. In the mythological scenes, where he applies a diagonal line to infuse greater life and dynamism, we can catch points taken from the antique statuary and Renaissance works which Rubens had studied, exercising himself in the reproduction of Italian painters.

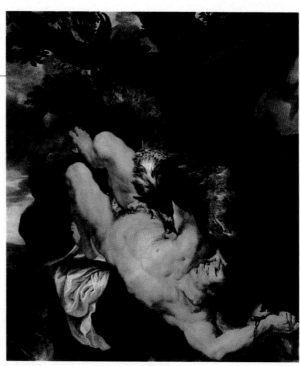

♦ PROMETHEUS (1612 ca., Philadelphia, Philadelphia Museum of Art). The work is a faithful copy of an original by Titian, and is done together with Frans Snijders, the painter of the eagle.

♦ THE ABDUCTION OF THE DAUGHTERS OF LEUCIPPUS (1616 ca., Munich, Alte Pinakothek). Rubens regroups the figures in the center of the picture, and describes their bodies with a monumental and tormented plasticity which will come to be recaptured by Gericault in his *Raft of the Medusa* (1810, Paris, Louvre). With the use of raw colors, he solidifies the figures in statue.

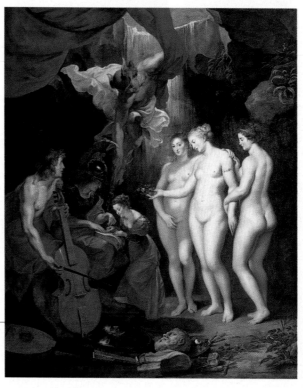

♦ THE EDUCATION OF MARIA DE' MEDICI (1622-25, Paris, Louvre). The allegorical composition reworks the Italian cues. In this way, Mercury who descends from above is a citation of Caravaggio.

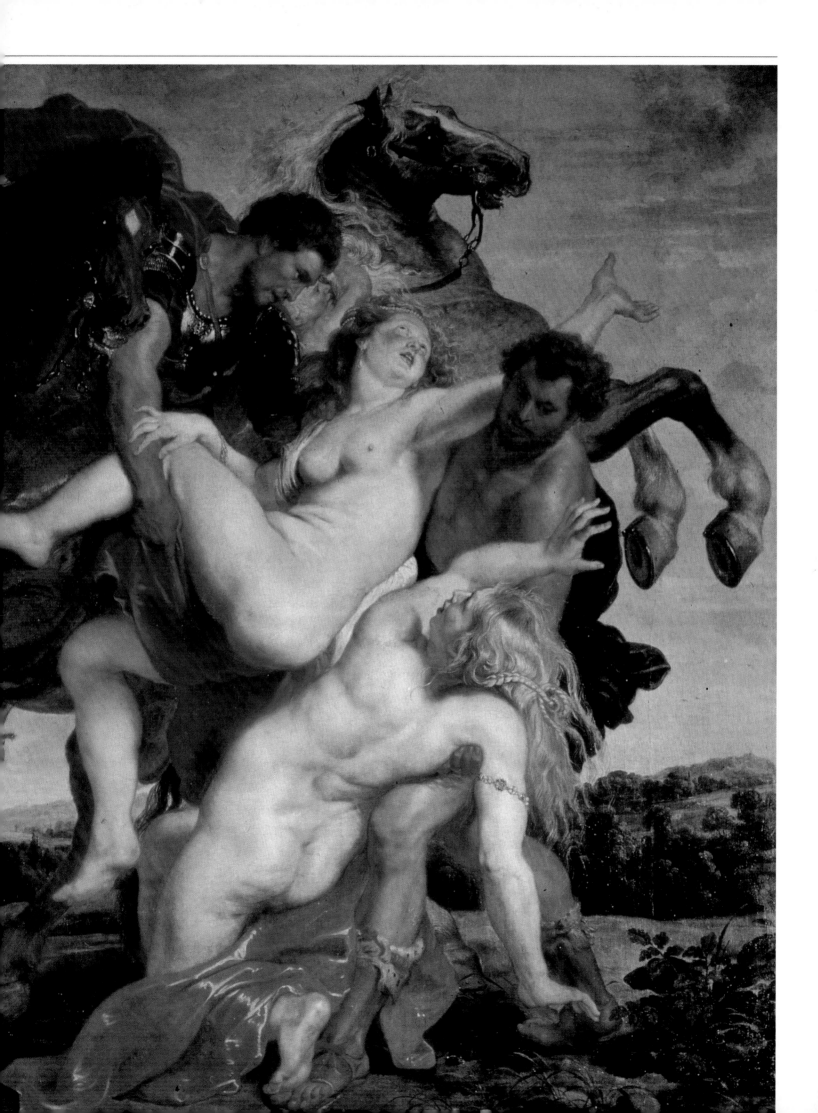

◆ ROMULUS AND REMUS
(1615-18, Rome,
Capitolina
Picture Gallery).
Rubens reviews on canvas
the legend of the origin
of Rome, in a sort
of tribute. The unusual
proportions
of the work, a square,
leaves us to suppose
that it was painted
on commission.
The painting reveals
a phase of transition
between the dark tones
typical of his stay in
Italy, and the luminosity
that characterizes his
later work.

◆ SUSANNA
AND THE ELDERS
(1607, Rome,
Borghese Gallery).
In spite of the Biblical
theme, the image has
a strong sensual charge
and recalls a work
of Tintoretto. The hand
of the young woman,
foreshortened,
infuses depth to the
composition and
introduces the dialogue
of gestures which binds
the figures. Cardinal
Borghese was perhaps
the commissioner
of the work.

◆ VENUS AT
HER MIRROR
(1613, Vaduz, Gallery
of Liechtenstein).
Here, Rubens
introduces that ideal
of opulent beauty which
will then become typical
of his work. In spite
of the still dominant
luminous contrast on
the dark background,
belonging to the Italian
production, the colors
are warm and soft.
The motif of the
woman at her mirror
proposes once again
the theme of *Vanitas.*

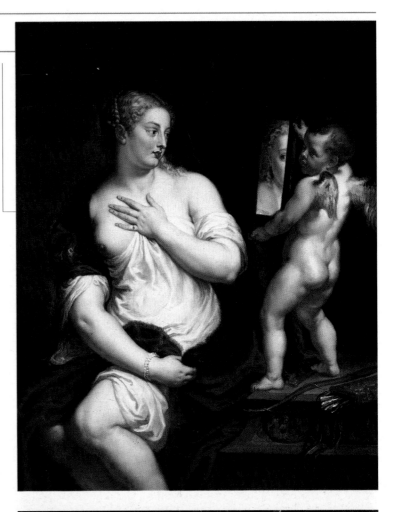

◆ TOILET OF VENUS (1628, Lugano, Thyssen-Bornemisza Collection). In 1628-29 Rubens stays in Madrid, where he has the chance to copy still more of the works of Titian, and to reinvigorate his tonalism by the light of the canvases of the Venetian master. But with respect to the original, the painter here accentuates the forms, and re-proposes the color contrast of the clothing in a personal way.

◆ PAOLO VERONESE *Venus and Sleeping Adonis* (1580 ca., Madrid, Prado). Veronese proposes a strongly hedonistic and sensual interpretation of profane subjects, characterized by soft forms, luminous and vibrant tones, and a refined atmosphere. Rubens recaptures its composite formulation, which gathers the figures at the center of the painting.

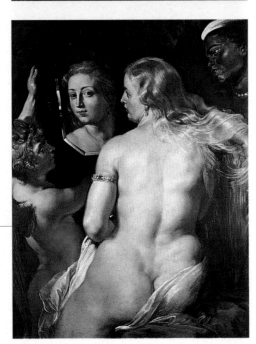

◆ EROS AND PSYCHE (1612-1615, Hamburg, Stödter Collection). The scene derives from the famous story by Apuleius in which he tells of the love between Eros and the young Psyche, who was forbidden to see the god. Rubens reproposes the luministic contrast of Caravaggesque descent between the background in shadow, and the torch, which, bursting through the darkness, reveals the two bodies.

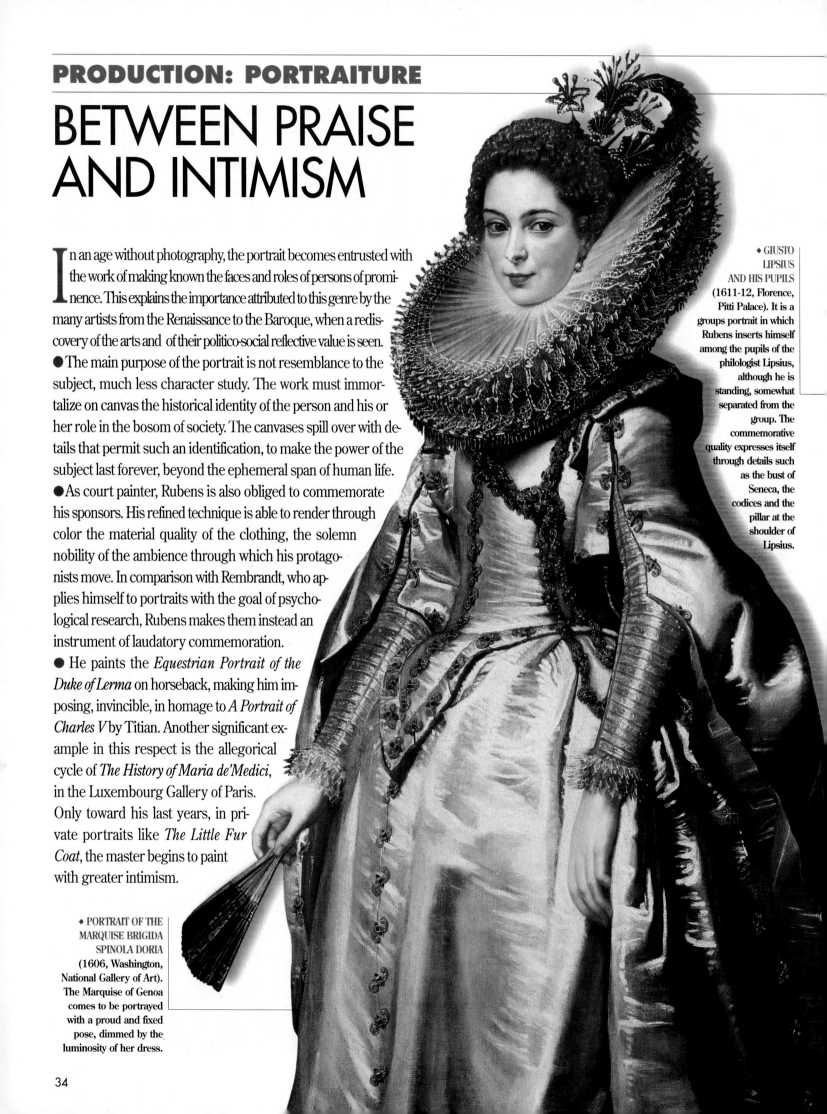

# BETWEEN PRAISE AND INTIMISM

In an age without photography, the portrait becomes entrusted with the work of making known the faces and roles of persons of prominence. This explains the importance attributed to this genre by the many artists from the Renaissance to the Baroque, when a rediscovery of the arts and of their politico-social reflective value is seen.

● The main purpose of the portrait is not resemblance to the subject, much less character study. The work must immortalize on canvas the historical identity of the person and his or her role in the bosom of society. The canvases spill over with details that permit such an identification, to make the power of the subject last forever, beyond the ephemeral span of human life.

● As court painter, Rubens is also obliged to commemorate his sponsors. His refined technique is able to render through color the material quality of the clothing, the solemn nobility of the ambience through which his protagonists move. In comparison with Rembrandt, who applies himself to portraits with the goal of psychological research, Rubens makes them instead an instrument of laudatory commemoration.

● He paints the *Equestrian Portrait of the Duke of Lerma* on horseback, making him imposing, invincible, in homage to *A Portrait of Charles V* by Titian. Another significant example in this respect is the allegorical cycle of *The History of Maria de'Medici*, in the Luxembourg Gallery of Paris. Only toward his last years, in private portraits like *The Little Fur Coat*, the master begins to paint with greater intimism.

◆ GIUSTO LIPSIUS AND HIS PUPILS (1611-12, Florence, Pitti Palace). It is a groups portrait in which Rubens inserts himself among the pupils of the philologist Lipsius, although he is standing, somewhat separated from the group. The commemorative quality expresses itself through details such as the bust of Seneca, the codices and the pillar at the shoulder of Lipsius.

◆ PORTRAIT OF THE MARQUISE BRIGIDA SPINOLA DORIA (1606, Washington, National Gallery of Art). The Marquise of Genoa comes to be portrayed with a proud and fixed pose, dimmed by the luminosity of her dress.

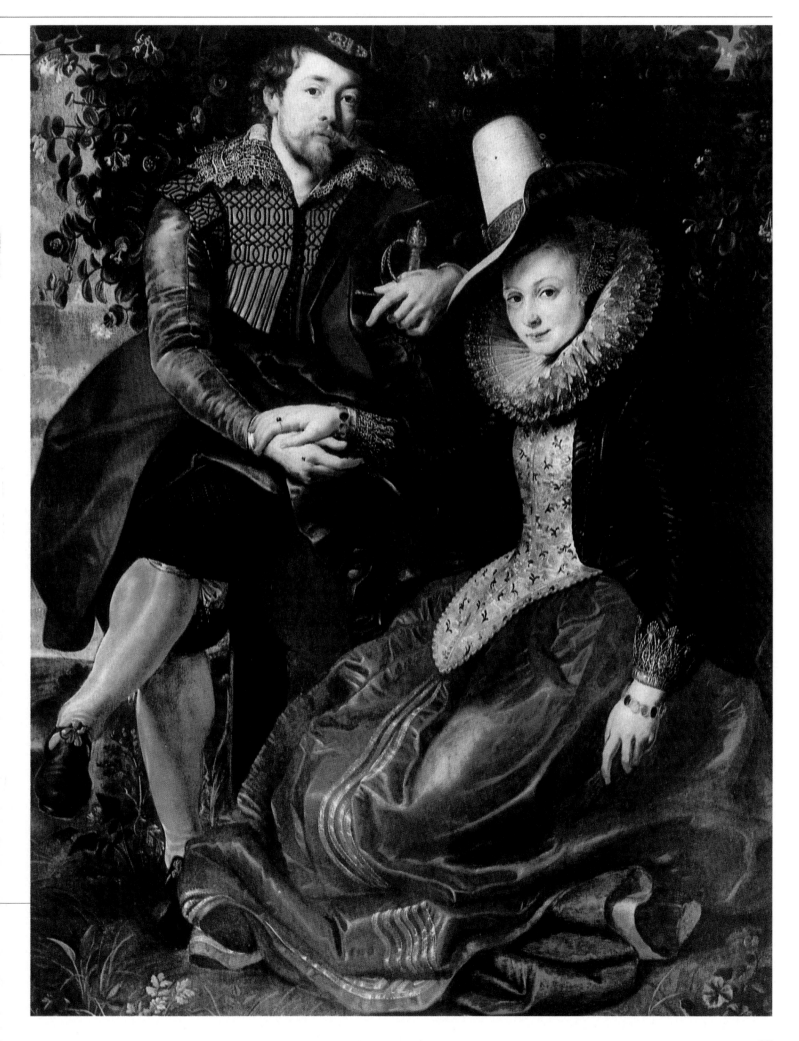

# THE EMOTION OF NATURE

Between the end of the sixteenth century and the seventeenth century, the difference between the pictorial genres reaches an extraordinary level of specialization. Artists appear who produce only still life, pictures of animals, or landscapes, subjects which suddenly acquire their own particular autonomy, and from being secondary details, taking on an individual dignity. Inside this thematic variety, a hierarchy can still be made out which maintains at its peak the representation of the human figure, to which the others are subordinated. Even Rubens entrusts the realization of details of animals or flowers in his canvases to specialized painters.

● When he acquires the Castle of Steen, his new residence in the country, in 1632, however, he discovers the charm of the rustic life, articulated with simple rhythms. The master thus makes an attempt at the painting of landscapes, and realizes for his own pleasure works of poetic lyricism. These canvases, outside of the sales circuit, are only placed on the market after his death.

● The central character of Ruben's landscape production is just the intimism. Arriving at this dedication in his mature years, the master immerses his nature in a dreamy, vibrant atmosphere, using a delicately shaded tonalism which betrays his affective participation in the subject. He introduces a delicate dynamism into the static nature of the traditional Flemish views, until he reveals his emotional involvement through the wide openness of his scenes, and the optimistic serenity of the people that are represented there. Serving himself to the aerial perspective proposed by Leonardo and from a particularly elevated point of view, Rubens frames the farmers in a joyous nature – where shines the light of a sunset or the spectrum of a rainbow – a nature animated with livestock, imbued with a domestic atmosphere. In these masterpieces of baroque painting, in which play curved and diagonal lines, soft, luminous contrasts and the fullness of chromatic timbre, the life of man is represented in harmony with the environment.

◆ RETURN FROM THE FIELDS (1632-34 ca., Florence, Pitti Palace, detail). The canvas, which describes the landscape near his residence at Steen, captures the vastness and serenity of nature. The figures, although concentrated in the foreground, merge harmoniously with the environment, and reanimate it with the red touches of their clothes. The warm tones of the painting, suffused with a soft light, are delicately shaded by glazing.

◆ LANDSCAPE WITH PHILEMON AND BAUCIS (1625, Vienna, Kunsthistorisches Museum). This nature, in balance between reality and fantastic vision, brimming with disastrous omens in the stormy sky, will inspire the English landscape artist, Turner, in his dramatic luminism. Notwithstanding the mythological theme, which imposes figures into the landscape, the representation of nature dominates, as if it were an autonomous subject.

◆ LANDSCAPE WITH RAINBOW (1635, Munich, Alte Pinakothek). The undulating profile of the countryside is peopled with animals and figures who exalt its vastness. In comparison with the Dutch tradition, which maintains an almost scientific detachment from the landscape, Rubens immerses himself in nature to the point of offering an emotional version of it, and of revealing on the canvas its mysterious life.

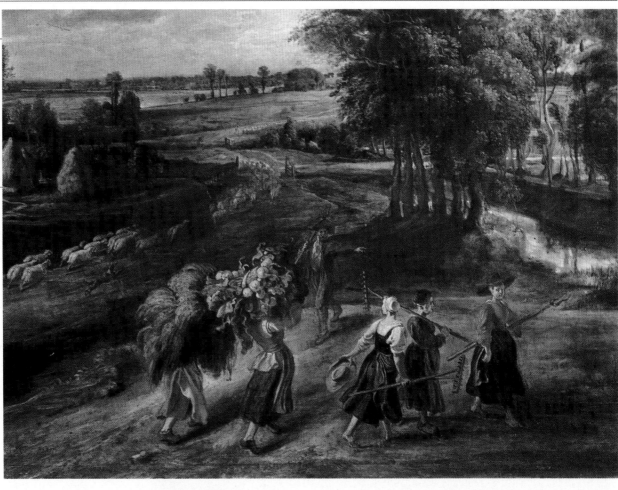

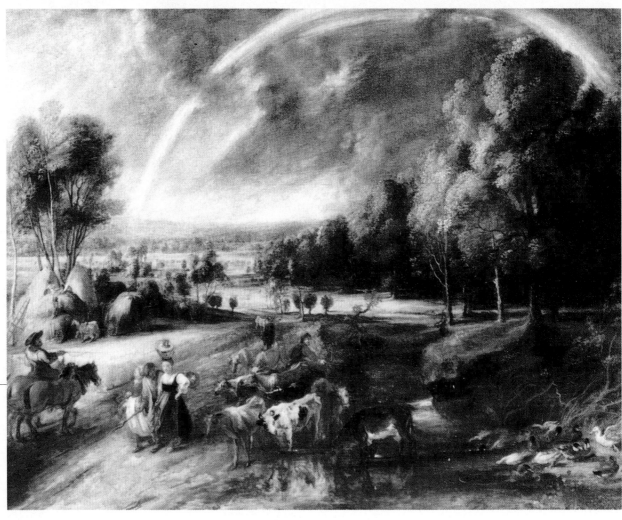

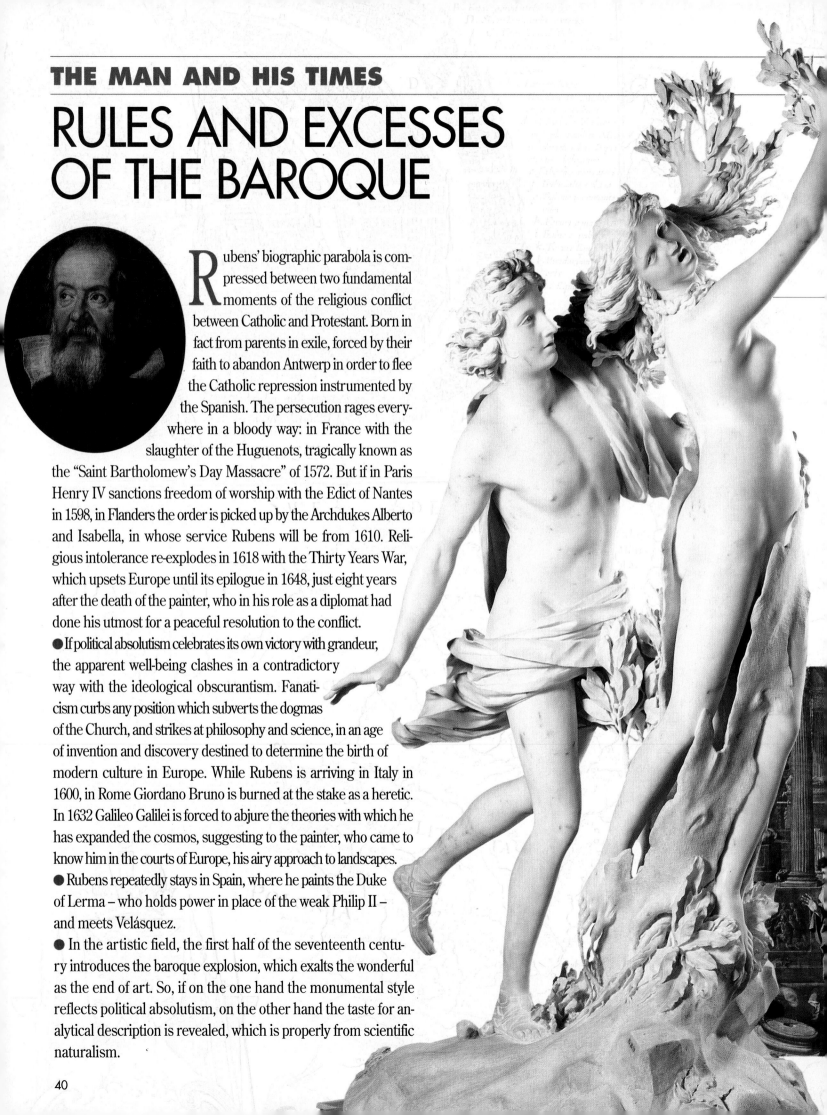

# RULES AND EXCESSES OF THE BAROQUE

Rubens' biographic parabola is compressed between two fundamental moments of the religious conflict between Catholic and Protestant. Born in fact from parents in exile, forced by their faith to abandon Antwerp in order to flee the Catholic repression instrumented by the Spanish. The persecution rages everywhere in a bloody way: in France with the slaughter of the Huguenots, tragically known as the "Saint Bartholomew's Day Massacre" of 1572. But if in Paris Henry IV sanctions freedom of worship with the Edict of Nantes in 1598, in Flanders the order is picked up by the Archdukes Alberto and Isabella, in whose service Rubens will be from 1610. Religious intolerance re-explodes in 1618 with the Thirty Years War, which upsets Europe until its epilogue in 1648, just eight years after the death of the painter, who in his role as a diplomat had done his utmost for a peaceful resolution to the conflict.

● If political absolutism celebrates its own victory with grandeur, the apparent well-being clashes in a contradictory way with the ideological obscurantism. Fanaticism curbs any position which subverts the dogmas of the Church, and strikes at philosophy and science, in an age of invention and discovery destined to determine the birth of modern culture in Europe. While Rubens is arriving in Italy in 1600, in Rome Giordano Bruno is burned at the stake as a heretic. In 1632 Galileo Galilei is forced to abjure the theories with which he has expanded the cosmos, suggesting to the painter, who came to know him in the courts of Europe, his airy approach to landscapes.

● Rubens repeatedly stays in Spain, where he paints the Duke of Lerma – who holds power in place of the weak Philip II – and meets Velásquez.

● In the artistic field, the first half of the seventeenth century introduces the baroque explosion, which exalts the wonderful as the end of art. So, if on the one hand the monumental style reflects political absolutism, on the other hand the taste for analytical description is revealed, which is properly from scientific naturalism.

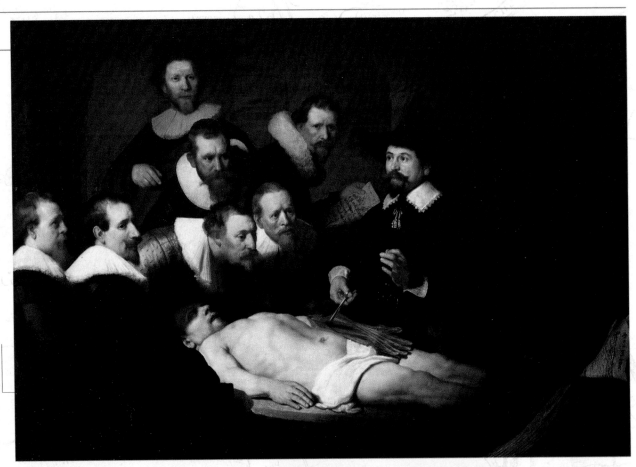

◆ GALILEO GALILEI
The scientist (1564-1642) – in the oval at the left in a portrait by Joost Susterman – was condemned for his heliocentric theory, which confirmed that of Copernicus.

◆ GIAN LORENZO BERNINI
*Apollo and Daphne* (1615-25, Rome, Borghese Gallery). The work expresses with elegance and virtuosity the fusion of human and plant.

◆ REMBRANDT VAN RIJN
*The Anatomy Lesson of Doctor Tulp* (1632, L'Aja, Mauritius). The canvas adds a scientific subject rendered with crude realism to the genre of group portraits.

◆ NICOLAS POUSSIN
*The Plague of Asdod* (1631, Paris, Louvre). In Paris, where he paints the cycle for Maria de'Medici, Rubens reveals a greater respect towards the tradition, which corresponds to the contemporary classicism of Poussin. If the former draws on erudition with ease, the latter, who frames even the tragic aspects of reality in classical and solemn rhythms, sometimes skims over citationism.

◆ WILLIAM SHAKESPEARE
Rubens, in London in 1629 for the signing of the peace treaty with Spain, discovers the work of the English playwright, (1564-1616), here portrayed by Louis Coblitz.

◆ DIEGO VELÁSQUEZ
*The Triumph of Bacchus* (1628 ca., Madrid, Prado). In 1628-29 Rubens is on a diplomatic mission to Madrid. Here he encounters Velásquez, with whom he visits the Escorial collections several times. Through the splendor and bright coloring of the master, Velásquez tempers the lesson of Caravaggio – evident here in the citation of Bacchus – and revives his naturalism.

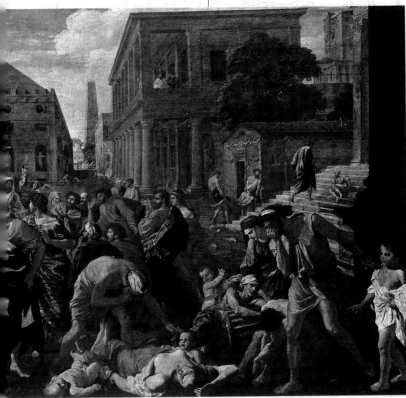

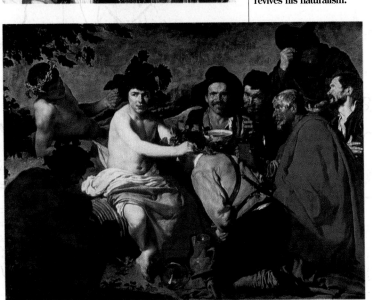

# THE POWER OF THE COLOR

Rubens aesthetic influence makes itself felt starting with his studio. In fact, painters of Antonie Van Dyck's caliber, who can only be improperly defined as his students, and were rather his collaborators, testify how capable they are of reelaborating autonomously the technique and style tranmitted to them by the master. In particular, Rubens leaves his models at their disposition, so that they can be reused. In this way, when Van Dyck paints his *Rest on the Flight to Egypt*, he unites the sweetness of the faces, with their usual soft profiles, with a search for naturalness and spontaneity typically Rubensian.

● In European circles, the lesson of the painter develops along two mutually discordant general themes, one which recovers his pre-arcadian themes, the other the plastic and emotive power of his colors. The former current prevails in portraiture and in the tradition of gallant celebrations and idylls, typical of the eighteenth century. Artists such as Boucher, Fragonard and Watteau, even

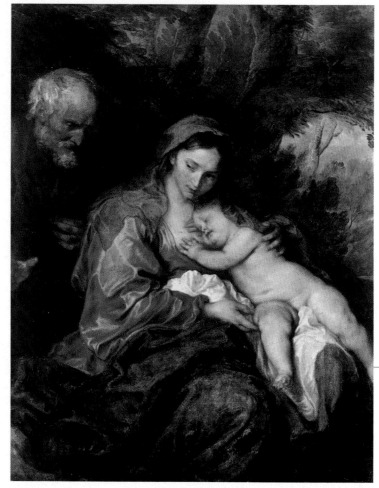

though opposing the carnality of Rubens with a more lovely and refined poetica, develop technical and thematic points derived from the happiness of his *Garden of Love*. In fact, in wide open naturalistic settings, they describe gallant themes characterized by a serene and affected atmosphere.

● On the other hand, Rubens' chromatic boldness asserts itself with bursting force in the early nineteenth century works of Delacroix and Gericault. The two French artists recover the physical power of the body that the Fleming had described in paintings such as *The Raising of the Cross* or *Universal Judgment*, and they translate it into tormented anatomical tangles in which citations to the master can often be identified. With their dramatic and violent use of colors, they translate into tragic and heroic settings and atmospheres the joyous emphasis of Rubensian painting.

● Still in France, a singular heir of Rubens' aesthetic is revealed in the impressionist painter Renoir, who, in his later work, already in the first part of the nineteen hundreds, creates sculptures of women and pictures of bathers characterized by florid and robust forms, in which he even reproposes the joyful coloring of the master. But the vitality of Rubens' constructive coloring reaches past the middle of the twentieth century, when, for example, it reappears in the canvases of Guttuso.

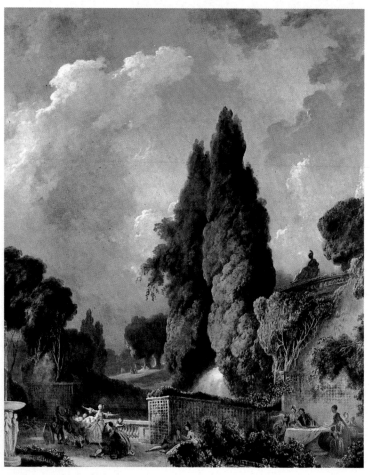

◆ EUGÈNE DELACROIX
*The Boat of Dante*
(1822, Paris, Louvre).
The power
of the physical forms
and the strong contrasts
of color which make
his compositions vibrate
are in part indebted
to Rubens, whom
Delacroix admired,
and, as his diaries
reveal, meticulously
studied for his
technique.

◆ ANTONIE VAN DYCK
*Rest on the Flight to Egypt*
(1630 ca., Munich,
Alte Pinakothek).
After having begun
his career as an
independent painter,
Van Dyck chose to enter
Rubens' studio, and he
became one of his most
faithful and accurate
interpreters. He
reproposes his soft
forms, his lyricism, and
the composed boldness
of his portraits.

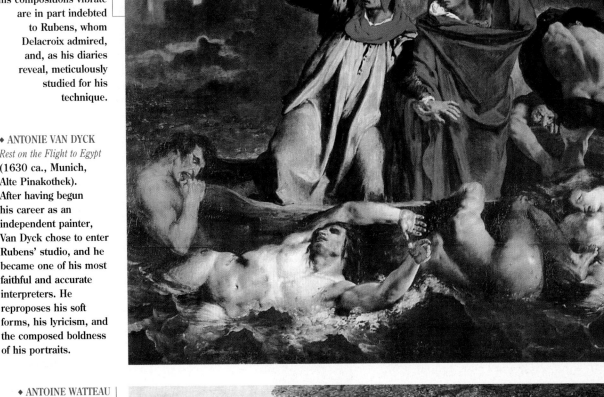

◆ ANTOINE WATTEAU
*Embarkation for Citera*
(1717-18, Berlin,
Charlottenburg Castle).
Even if with greater
theatricality, Watteau
was one of the main
heirs of Rubens' joyous
eroticism. In this
canvas, he reproposes
the mixing of the real
plane and the
allegorical plane of *The
Garden of Love*.

◆ HONORÉ FRAGONARD
*Blindman's Buff*
(1773-76, Washington,
D.C., National Gallery
of Art). In his work, the
eighteenth century
painter recaptures the
thematic range affiliated
with the diversions of
high society and gallant
love. He thus gives life
to small, idyllic
pictures, in which his
figures, immersed in a
cultured and elegant
nature, are almost used
as a pretext.

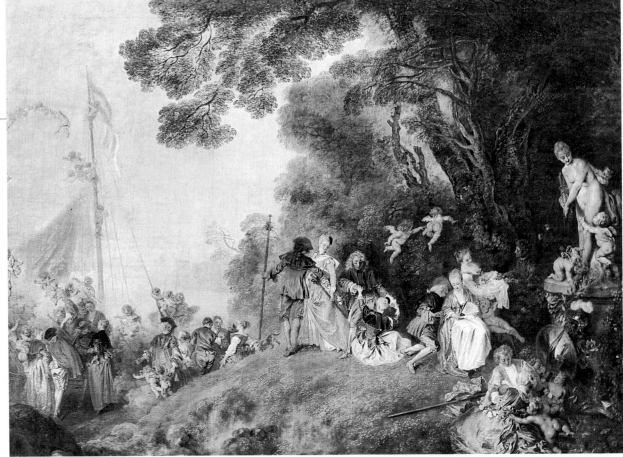

# THE ARTISTIC JOURNEY

For a vision of the whole of Rubens' production, we propose here a chronological reading of his principal works.

### ◆ THE JUDGMENT OF PARIS (1600-1601)

With this mythological subject, Rubens demonstrates a treatment of the landscape and of the figures still tied to the Renaissance model. The poses of the three models bring back a memory of Julius Romano and Venetian painting, while Paris evokes one of the Caravaggesque characters from *The Vocation of Saint Matthew*. The canvas was perhaps painted on commission from Vincenzo Gonzaga.

### ◆ DEPOSITION IN THE SEPULCHRE (1601-02)

This is one of the first canvases done in Italy. The sarcophagus upon which the body is settled is a citation of those in ancient Rome, and shows scenes of sacrifice which allude to the meaning of the Passion. The foreshortening of the feet of Christ is an expedient for the creation of depth; the contrast between his bluish hand and the living one of Magdalena emphasizes the tragic tone of the subject.

### ◆ EQUESTRIAN PORTRAIT
### OF THE DUKE OF LERMA (1603)

The model for this equestrian portrait is the *Charles V* painted by Titian in 1548, which Rubens was able to see in Spain. The impressive pose of the armed Duke is tied to the battle scene which is unfolding in the background and alludes to his valor in war. The Duke had an important political and military role, governing in place of the weak King Philip III.

### ◆ PORTRAIT OF THE MARQUISE
### BRIGIDA SPINOLA DORIA (1606 ca.)

The work was severely mutilated, suffering a common fate with other canvases done by Rubens for the Gonzaga family. The Marquise is portrayed in front of her residence in Genoa, where Rubens stayed for a long time, and is rendered in all her elegance, with a Spanish style dress dominated by a huge ruff.

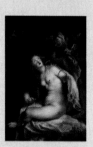

### ◆ SUSANNA AND THE ELDERS (1607)

The work was done by Rubens following a Venetian model of composition which goes back to Tintoretto. The canvas is of uncertain dating: there are plenty of hypotheses that refer it to 1601-02, but we are probably speaking of a work done later, in Rome. The illustration of the episode is entrusted to the exchange of gestures between the men and the woman, with great narrative synthesis.

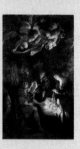

### ◆ ADORATION OF THE SHEPHERDS (1608)

While he is in Rome, the canvas comes to be commissioned to Rubens by the Oratorians, for whom he was painting the altarpiece for Church of Santa Maria of the Vallicella. The luminous contrast, determined by the sudden and plastic glow of light from the darkness of the surroundings, testifies to Rubens' profound assimilation of the work of Caravaggio.

### ◆ BATTLE OF ANGHIARI
### (COPY OF LEONARDO) (1600-08)

The copy of Leonardo becomes an opportunity for Rubens to educate his brush to the plastic rendering of bodies in movement. He draws from this model even for his *Defeat of Sennacherib*. On the base of this copy on cardboard, he paints, circa 1605, the canvas of *Battle for the Standard*, in which he accentuates the vorticism of the original.

### ◆ ANNUNCIATION (1609-10)

In this scene, Rubens revolutionizes the traditional position of the angel – who should come from the left, not the right – and of the Virgin, caught as usual while she is reading intently. The room of the Madonna has been ennobled with respect to the Biblical sources, which underline instead her poverty. The work, made dramatic by the diagonal lines, reveals the influence of Tintoretto.

### ◆ SELF-PORTRAIT WITH ISABELLA BRANT
### (1609-10)

This double portrait presents Rubens together with the young wife he married in 1609. The landscape-like setting, which acts as a decorative background, contributes to the framing of the two figures. Developing itself towards open space lightens and renders harmonic the composition, which is based on a closed oval line.

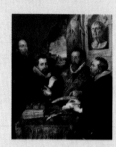

### ◆ GIUSTO LIPSIUS AND HIS PUPILS (1611)

This multiple portrait depicts Giusto Lipsius with some pupils in a setting in which various objects symbolically contribute to commemorate the role of the master. The bust of Seneca and the books on the table allude to the exegetical work of the philologist; the pillar placed in relation to him underlines his magistral authority. Rubens portrays himself standing, separated from the group.

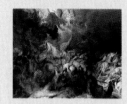

### ◆ DEFEAT OF SENNACHERIB (1614-15)

The painting, destined to strongly influence Delacroix and Gericault, is constructed as if it were a whirlpool, in which the convulsion of movements is mixed with the intertwining of the bodies. Two horses are clashing in the center. The centrifugal motion of the scene is heightened by the broad brushstrokes. Rubens is interpreting in an original way the suggestion from *The Battle of Anghiari* by Leonardo.

### ◆ UNIVERSAL JUDGMENT (1615-16)

The work, of enormous proportions (606cm x 460cm), is done with the decisive help of the studio, whom Rubens furnishes with preparatory sketches. The model is the *Universal Judgment* of Michelangelo. The excess nudity in the original in the Sistine Chapel, which provoked the censorial intervention of the painter Daniele da Volterra, proved harmful also to Rubens' work, which was removed.

### ◆ ROMULUS AND REMUS (1615-18)

The work, which treats the legendary origins of Rome, was done in Antwerp. This, together with the unusual square dimensions of the canvas, has led us to believe that it was painted on commission, about which, however, precise information is missing. At the center of the composition the birds stand out for their realism and brilliant tones, autographed details which reveal Rubens' virtuosity.

### ◆ MADONNA IN A GARLAND OF FLOWERS (1620)

This work is one of the few religious canvases of private nature and reduced dimensions. Rubens painted the Virgin and the Child; the floral frame, of almost photographic realism, however, was done by Jan Bruegel the Velvet, particularly expert in the painting of such still lifes. At that time it was common to divide work in a studio on the basis of each person's specialization.

### ◆ EDUCATION OF MARIA DE' MEDICI (1622-25)

This allegorical painting has an accentuated Baroque flavor, evident in the galaxy of brightly lit colors, the soft atmosphere, and the richness of descriptive detail. The pagan divinities – Mercury, Minerva, and the Three Graces – are painted larger than the protagonist Maria de'Medici, to indicate their guiding role.

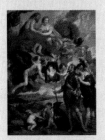

### ◆ PORTRAIT OF MARIA DE' MEDICI PRESENTED TO HENRY IV (1622 ca.)

Recent events can be made out in the allegory of the scene. The wedding of Maria de'Medici and Henry IV is celebrated at the conclusion of a tormented period of war. The king is armed, and while Minerva exhorts him to wisdom, the smoke of the destruction is still rising on the horizon. Jove and Juno allude to the wedding of sovereigns from on high.

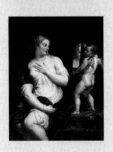

### ◆ TOILET OF VENUS (1628)

For its theme and the soft sensuality of the woman, the painting shows traces of the inspiration of *Young Woman at Her Mirror* by Titian, which Rubens sees in Madrid. Titian is one of his principal models, above all in his mature phase, when his brushwork frays and makes the atmosphere vibrate, just as happens in the late production of the Venetian painter.

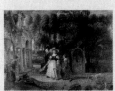

### ◆ PORTRAIT WITH HÉLÈNE FOURMENT IN THE GARDEN OF ANTWERP (1631)

The portrait of the couple with one of the children from Rubens' first marriage captures a moment of the painter's private life, at once concrete and intimate. The richness of nature is described through the flowers, the peacocks, the airiness of the trees. The appearance of the garden, with fountains and domestic animals, reflects a fashion of the time.

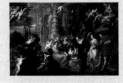

### ◆ THE GARDEN OF LOVE (1632-33)

The canvas was painted by Rubens for his own pleasure, but soon ended up decorating the bedroom of King Philip IV in Madrid. There exist numerous preparatory drawings for the painting, which show the care put in to the project, and thus the value of the work for the artist. The sixteenth century style architecture in the background is that of the portal to his villa in Antwerp.

### ◆ RETURN FROM THE FIELDS (1632-34)

The picture is painted in Rubens' new country residence, the castle of Steen, where the painter discovers the charm of a simple life paced by regular rhythms. Thus, even the working tools are described in a poetic way. The highly raised point of view accentuates the effect of the vastness of nature, together with the figures gathered in the foreground, who are pressing outwards.

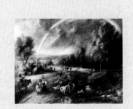

### ◆ LANDSCAPE WITH RAINBOW (1635)

Rubens' landscapes are inspired by a sense of eternity and by the vastness of nature. The figures here are serenely immersed in the environment, notwithstanding the thickening of the clouds on the horizon. The soft degrading of the landscape and of the colors comes to be reanimated by the animals that populate the countryside. In this way, Rubens makes the mysterious force of nature emerge on his canvas.

### ◆ ABDUCTION OF THE SABINES (1635-36)

This painting inspired Delacroix and Géricault. In his turn, Rubens drew the formal and compositive motifs from the canvas of Tintoretto. The scenic setting recalls Roman architecture, while in the women figures the physiognomical typology already codified by the painter can be identified: the round faces, the blond heads of hair, and the carnal sensuality which seeps out even in this dramatic moment.

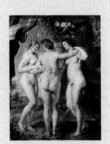

### ◆ THREE GRACES (1636-38)

The subject, which goes back to the Greco-Roman tradition, is well known in the figurative arts and in literature as a canonical reference to beauty. In the Renaissance it frequently asserts itself, and perhaps the idealized version of Raphael is most famous. With the anatomical characteristics strongly accentuated and the colors warm, Rubens paints a version instead which follows the Baroque aesthetic.

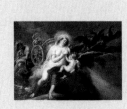

### ◆ ORIGIN OF THE MILKY WAY (1636-38)

The painting, which develops its theme starting with a mythological episode, has a second title: *Juno Nursing Hercules*. The features of the young Hélèna Fourment are once again recognizable in the face of the goddess. Even the gesture of Juno, squeezing her breast to extract milk, had already appeared in the fountain of Venus in *Garden of Love*, from 1632-34.

### ◆ THE LITTLE FUR COAT (1638)

This curious portrait of Hélèna Fourment, nude and just enough wrapped with a fur not to offend modesty, provoked a heavy scandal. In reality, an affectionately intimate motion seeps out, in the way Rubens underlines the softness of the forms and suggests the charm of his young wife, to whom he leaves the work, as is indicated in his will.

### ◆ SELF-PORTRAIT (1639)

The painting portrays Rubens during the last years of his life, when, by now stricken with gout, he can only rarely dedicate himself to painting. The disease especially struck his right hand, which is covered with a glove in the portrait. The proud and distant expression on his face is accentuated by the contrast between the light, and the dark tones of the black mantle and the faintly-lit surroundings.

# TO KNOW MORE

The following pages contain: some documents useful for understanding different aspects of Rubens' life and work; the fundamental stages in the life of the artist; technical data and the location of the principal works found in this volume; an essential bibliography.

## DOCUMENTS AND TESTIMONIES

### Epistolary Confessions

"No undertaking, no matter how boundless were the quantity and variety of subjects, has ever overcome my courage."
[Rubens, *letter of 1621*]

"I confess to be more adapted by natural instinct to the making of grand works than little curios."
[Rubens, *letter of 1635*]

### The God of Painters

"We have here a great painter whom we call the god of painters, Pieter Rubens, who is the painter for His Highness. He has painted various works here that are highly estimated and which are found in the city, in Saint-Michel, with the Dominicans in the church at Bourg; they are beautiful."
[Anonymous, *Letter in response to a merchant asking who is the best painter in Antwerp*, 1611]

"In his lightest sketches, Rubens puts a heart and spirit which shows the speed with which he conceives and executes his own thoughts. But when he polishes it up, then, he loses nothing of that spirit, which only becomes more measured, adding all the diverse components of painting that a man could possess in the highest degree, in particular that of chiaroscuro, all that he could imagine to make them perfect works."
[Pierre-Jean Mariette, *"Primer and other unedited notes by this amateur on the arts and artists,"* Paris, 1858-59]

### The Universal Talent

"Rubens thus lived honored for his merits and for his noble and sincere customs. He was of grand stature, well formed and of good nature and temperament; he was lofty yet human, noble of manner and habit; he would put a gold chain around his neck and ride off to the city."
[G.P. Bellori, *The Lives of Modern Painters, Sculptors and Architects*, Rome, 1672]

"He had a natural gift, bright spirit, and universal and noble talent, cultivated in the writings of the great authors of history and poetry, from which he was capable of invention, and knew how to explain subjects with the most appropriate and opportune parties. He was effective in his actions, through which he expressed and animated motions and affections."
[G.P. Bellori, *The Lives of Modern Painters, Sculptors and Architects*, Rome, 1672]

"He gathered marble works and statues, and he had brought from Rome every sort of antiquity, medal, cameo, engraving, gem and metal; and he built a round room in his home in Antwerp with a single eye in the ceiling in imitation of the Rotunda of Rome, identical in the perfection of the light, and in this he placed his precious museum."
[G.P. Bellori, *The Lives of Modern Painters, Sculptors and Architects*, Rome, 1672]

### The Rubens of Delacroix

"Through his crude colors and rough figures, Rubens arrives at a spirituality of the mightiest. Strength, vehemence and magnificence exempt him from grace."
[Delacroix, *Journal,* 1847]

"The truly great men are perhaps, and I believe without a doubt, those who have preserved, at an age when their intelligence has all its strength, a part of that violence in their impressions which is the characteristic of youth. I found myself wondering why the extreme ease and boldness of brush don't bother me in Rubens, while they are nothing but hateful qualities in Van Loo."
[Delacroix, *Journal,* 1849]

### The Writers' Rubens

"The *Crucifixion* is a work apart, and when Rubens painted it he was thinking of Michelangelo. The drawing is tough and wild, violent like those of the Roman school: muscles bursting all together, bones and cartilage evident, nerves of steel lifting rods of granite. We are no longer talking of that joyous vermilion with which the painter from Antwerp abundantly strews his numerous works; it is instead the Italian bistre with its aggressive intensity: the executioners, colossi like elephants, have faces like tigers, movements of bestial ferocity; the same Christ, participating in such exageration, looks more like a Milo of Crotone nailed to a rack by rival athletes than like a God who sacrificed himself voluntarily for the redemption of humankind. [...]
When the shutters for the *Descent from the Cross* were thrown open, Tiburce experienced a sense of vertigo, of dizziness, as if he were looking into an abyss of light: the sublime head of the Magdalena burning triumphantly in an ocean of gold, and the rays from her eyes seemed to illuminate the gray and livid atmosphere filtered through the narrow Gothic windows. Everything dissolved around him; he became totally empty and saw nothing more."
[Theophile Gautier, *The Golden Fleece,* 1839]

"Rubens , river of forgetfulness, garden of/ lazy indolence, pillow of flesh,/ where you cannot love, but where life tumbles and flows without rest, /like air in the sky and water in the sea."
[Baudelaire, *The Beacons,* 1857-68]

## HIS LIFE IN BRIEF

**1577.** Peter Paul Rubens is born in Siegen, Westfalia, to parents in exile. His family must in fact flee the repressions with which catholic Spain disturbs Flanders during the Counter-Reformation. His father, Protestant, is thus forced to find refuge in Germany.

**1587.** At the death of his father, and thanks to the religious truce of 1585, he can return to Antwerp, where he attends a Latin school.

**1591.** After attending the studio of Tobias Verhaecht, italian-style landscape painter, he enters that of Adam Van Noort, who teaches him the heirarchy of thematic genres.

**1594.** He initiates his third apprenticeship, care of the master Van Veen, called Vaenius, with whom he remains for four years. By Vaenius, who has been to Rome, he is urged to travel to Italy to complete his artistic education.

**1598.** He joins the Guild of San Luca, the artists' guild, and is thus able to open an autonomous studio.

**1600.** Rubens leaves for Italy, where he stays until 1608. In Venice he meets Vincenzo Gonzaga I, who recruits him as his court painter. He thus moves to Mantova, but travels frequently throughout the peninsula, where he visits the most well-known centers of art and copies ancient and modern works of art, from Leonardo and Michelangelo to the *Torso of Belvedere*.

**1603.** As ambassador for the Duke Vincenzo Gonzaga he is sent to Madrid. Here, he meets Velásquez and visits the Escorial with him. In Spain, he paints *Equestrian Portrait of the Duke of Lerma*.

**1604.** Having returned to Mantova, he paints *The Trinity, Worshipped by the Gonzaga Family*.

**1606.** He stays at length in Genoa at the court of the Doria family. He studies the architecture of the city and does various drawings of the palaces, which he will then use when he publishes the text *Palaces of Genoa* in 1622. Paints the *Marquise Brigida Spinola Doria*. Moving to Rome, he works on the *Altarpiece* for the Oratorian church of Santa Maria of Vallicella.

**1608.** Reached by the news of the grave condition of his mother's health, he precipitously returns to Antwerp. Abandoning his Italian sponsors, he finds himself an unknown artist in Flanders again.

**1609.** He marries the youthful Isabella Brant who is 14 years younger than him. Supported by his brother and other friends, he becomes court painter and can organize his own studio. He paints the portrait of the *Archduchess Isabella*. The following year he attends to the altarpiece with *Raising of the Cross* for the Cathedral of Antwerp.

**1614.** He works on *Universal Judgment* and on *Battle of Sennacherib*. Three years after the birth of his first-born daughter Clara, his son Albert is born to him.

**1618.** He works on *Miracles of Saint Ignatius*. His third son Nicolaas is born.

**1626.** His wife Isabella dies, two years from the death of his first-born Clara. Stricken with grief, he takes to travel again and goes to Spain, where he stays for four years at the court of Philip IV. In Paris, he works on *History of Maria de' Medici* in Luxembourg Palace.

**1630.** Having returned to Antwerp, he marries for the second time with Hélène Fourment, who is just 16 years old and who will give him five children. The more or less altered face of the young woman recurs in all the last canvases of the painter. He is knighted. The University of Cambridge confers an honorary degree on him for his diplomatic commitment in the peace treaty of the preceding year.

**1632-34.** He paints the *Garden of Love*, and the double portrait *With Hélène in the Garden*. He suffers from gout with progressive intensity. Mainly his hands are struck, to the point where it is often impossible to paint. His style thus becomes softer and his brushwork more fractured. He begins to paint landscapes.

**1636.** The Spanish King Philip IV commissions him to decorate his hunting lodge at Torre de la Parada. He does sketches for the tapestries.

**1640.** In February he is named honorary member of the Academy of San Luca in Rome. He dies on May 30, after a violent attack of gout.

## WHERE TO SEE RUBENS

*The following is a listing of the technical data for the principal works of Rubens that are conserved in public collections. The list of works follows the alphabetical order of the cities in which they are found. The data contain the following elements: title, dating, technique and support, size expressed in centimeters.*

BERGAMO (ITALY)
**Bust of Saint Domitilla,** 1606; oil on paper glued to wood, 89.7x69.2; Carrara Academy.

COLOGNE (GERMANY)
**Holy Family,** 1632-34 ca.; oil on canvas, 118x98; Wallraf-Richartz Museum.

FERMO, ITALY
**Adoration of the Shepherds,** 1608; oil on canvas, 300x192; Civic Picture Gallery.

FLORENCE (ITALY)
**Giusto Lipsius and His Pupils,** 1611-12; oil on wood, 164x138; Pitti Palace.

**Resurrection of Christ,** 1616; oil on canvas, 183x155; Pitti Palace.

**Three Graces,** 1622; sanguine on wood, 47.5x35; Palatina Gallery.

**The Infant Isabella Clara Eugenia of Spain in Clarissa's Dress,** 1625; oil on canvas, 116x96; Palatina Gallery.

**Return from the Fields,** 1632-34; oil on wood, 122x195; Pitti Palace.

GENOA (ITALY)
**Portrait of Giovanni Carlo Doria on Horseback,** 1606; oil on canvas, 265x188; Liguria National Gallery, Spinola Palace.

LONDON (ENGLAND)
**Portrait of Suzanne Fourment,** 1622 ca.; oil on wood, 79x54; National Gallery.

**Judgment of Paris,** 1632-35 ca.; oil on wood, 144.8x193.7; National Gallery.

**Landscape with Rainbow,** 1636-38; oil on wood, 136.5x236.5; Wallace Collection.

**Abduction of the Sabines,** 1635-37 ca.; oil on wood, 170x236; National Gallery.

47

**LUGANO** (SWITZERLAND)
**Holy Family with the Lamb,** 1620 ca.; oil on canvas, 151x113; Bornemisza Fondation.

**Toilet of Venus,** 1628; oil on canvas, 137x111; Bornemisza Fondation.

**MADRID** (SPAIN)
**The Mystical Contemplation of Saint Augustine,** 1615 ca.; oil on canvas, 243x187; Royal Academy of San Fernando.

**Garden of Love,** 1632-34; oil on canvas, 198x283; Prado.

**Three Graces,** 1636-38; oil on wood, 221x181; Prado.

**The Rape of Ganimede,** 1636-38; oil on canvas, 181x87; Prado.

**Origin of the Milky Way,** 1636-38; oil on canvas, 181x244; Prado.

**MUNICH** (GERMANY)
**Self-portrait with Isabella Brant,** 1609-10; oil on canvas, 174x143; Alte Pinakothek.

**Defeat of Sennacherib,** 1614-15; oil on wood, 97.7x122.7; Alte Pinakothek.

**Landscape with Cattle,** 1618-19; oil on wood, 81x106; Alte Pinakothek.

**Portrait with Hélène Fourment in the Garden of Antwerp,** 1631; oil on wood, 97.5x130.8; Alte Pinakothek.

**Hélène Fourment with their son Frans,** 1635 ca.; oil on wood, 146x102; Alte Pinakothek.

**NEW YORK** (UNITED STATES)
**Woods at Dawn with Deerhunt,** 1635 ca.; oil on wood, 62.2x90.2; Metropolitan Museum of Art.

**Self-portrait with Hélène Fourment and their son Peter,** 1639 ca.; oil on wood, 203x158.1; Metropolitan Museum of Art.

**PARIS** (FRANCE)
**The Battle for the Standard (copy from Leonardo),** 1600-08; crayon on paper, 45.2x63.7; Louvre, Cabinet des Estampes.

**Supper at Emmaus,** 1610; oil on canvas, 205x188; Saint-Eustache.

**Education of Maria de' Medici,** 1622-25; oil on canvas, 394x295; Louvre.

**Hélène Fourment Leaving in a Carriage,** 1639; oil on canvas, 19.5x13.2; Louvre.

**ROME** (ITALY)
**Laying to Rest in the Sepulchre,** 1601-02; oil on canvas, 180x137; Borghese Gallery.

**Martyrdom of Saint Sebastian,** 1602-03 ca.; oil on canvas, 153x118; Corsini Gallery.

**Greater Altarpiece,** 1606-08; oil on slate; Santa Maria in Vallicella.

**Susanna and the Old Men,** 1607; oil on canvas, 94x67; Borghese Gallery.

**Romulus and Remus,** 1617-18; oil on canvas, 210x212; Capitolina Picture Gallery.

**SAINT PETERSBURG** (RUSSIA)
**Adoration of the Shepherds,** 1608; oil on wood transferred to canvas, 63.5x47; Ermitage.

**VERONA** (ITALY)
**Lady of the Licnidi,** 1602; oil on canvas, 76x60; Castelvecchio Museum.

**VIENNA** (AUSTRIA)
**Eleonora Gonzaga at Two Years of Age,** 1600-01; oil on canvas, 76x48.5; Kunsthistorisches Museum.

**Judgment of Paris,** 1602 ca.; oil on copper, 32.5x43.5; Gemäldegalerie der Akademie der Bildenden Künste.

**The Battle for the Standard,** 1605 ca.; oil on canvas, 82.5x117; Gemäldegalerie der Akademie der Bildenden Künste.

**Portrait of Vincenzo Gonzaga II** (fragment of the *Mantova Trinity Piece*), 1605; oil on canvas, 67x51.5; Kunsthistorisches Museum.

**The Virgin in Glory,** 1608; oil on canvas, 86x57; Gemäldegalerie der Akademie der Bildenden Künste.

**Annunciation,** 1609-10; oil on canvas, 224x220; Kunsthistorisches Museum.

**The Medusa,** 1618 ca.; oil on canvas, 68x119; Kunsthistorisches Museum.

**Landscape with Philemon and Baucis,** 1626; oil on wood, 146x208.5; Kunsthistorisches Museum.

**Self-portrait,** 1638-39; oil on canvas, 109.5x85; Kunsthistorisches Museum.

**WASHINGTON, D.C.** (UNITED STATES)
**Portrait of the Marquise Brigida Spinola Doria,** 1606 ca.; oil on canvas, 152x99 (cut down); National Gallery of Art.

# BIBLIOGRAPHY

The following list furnishes some guides useful for obtaining the first instruments of orientation and information on the artist.

**1672** G.P. Bellori, *Le vite de' pittori, scultori e architetti moderni*, Roma

**1898** J. Burckhardt, *Erinnerungen aus Rubens*, Basle

**1933** P.C. Sutton, *The Age of Rubens*, Boston

**1955** F. Zeri, *Un ritratto di Pietro Paolo Rubens a Genova*, in "Paragone", 67, pp. 46-52

**1977** M. Jaffé, *Rubens in Italy*, Oxford, Italian ed. 1984, Roma

**1980** A. Pallavisni, *Rubens*, Milano

**1981** G. Mulazzani, *Tout Rubens. La peinture*, 2 vol., Paris

**1983** M. Gregori, *Rubens e Firenze*, Firenze

**1984** S.C. Coffrey, *Pieter Paul Rubens*, Los Angeles

**1985** R. Nuffel, *Rubens tra classicismo e barocco*, Cinisello Balsamo

**1989** G. C. Argan, *L'arte barocca*, Roma

M. Jaffé, *Rubens. Catalogo completo*, Milano

J. Muller, *Rubens: the Artist as a Collector*, Princeton

**1990** D. Bodart, *Pietro Paolo Rubens*, Roma

M. e R. Mainstone, *Il Seicento*, Milano

AA.VV., *Rubens e l'eredità veneta*, Venice

AA.VV., *Rubens e Roma,* exhibition catalogue, Roma

D. Bodart, *Rubens e la pittura fiamminga del '600*, Cagliari

AA.VV. *Rubens. 1577-1640*, Exhibition catalogue, Milano

**1991** M. Morford, *Stoics and Neostoics, Rubens and the Circle of Lipsius*, Princeton

**1993** R. Hagen, *Bildbefragungen*, Köln

**1995** A. Svetlana, *The Making of Rubens*, New Haven-London

Chagall
*The Falling Angel*

Dali
*The Persistence of Memory*

Kandinsky
*The First Abstract Watercolour Painting*

Leonardo
*The Last Supper*

Manet
*Le déjeuner sur l'herbe*

# ONE HUNDRED PAINTINGS:

### every one a masterpiece

The Work of Art. Which one would it be?
...It is of the works that everyone of you has in mind that I will speak of in "One Hundred Paintings". Together we will analyse the works with regard to the history, the technique, and the hidden aspects in order to discover all that is required to create a particular painting and to produce an artist in general.

It is a way of coming to understand the sensibility and personality of the creator and the tastes, inclinations and symbolisms of the age. The task of "One Hundred Paintings" will therefore be to uncover, together with you, these meanings, to resurrect them from oblivion or to decipher them if they are not immediately perceivable. A painting by Raffaello and one by Picasso have different codes of reading determined not only by the personality of each of the two artists but also the belonging to a different society that have left their unmistakable mark on the work of art. Both paintings impact our senses with force. Our eyes are blinded by the light, by the colour, by the beauty of style, by the glancing look of a character or by the serenity of all of this as a whole. The mind asks itself about the motivations that have led to the works' execution and it tries to grasp all the meanings or messages that the work of art contains.

"One Hundred Paintings" will become your personal collection. From every painting that we analyse you will discover aspects that you had ignored but that instead complete to make the work of art a masterpiece.

Federico Zeri

## Coming next in the series:

**Matisse, Magritte, Titian, Degas, Vermeer, Schiele, Klimt, Poussin, Botticelli, Fussli, Munch, Bocklin, Pontormo, Modigliani, Toulouse-Lautrec, Bosch, Watteau, Arcimboldi, Cezanne, Redon**

Raphael
*School of Athens*

Rembrandt
*Supper at Emmaus*

Renoir
*Moulin de la Galette*

Rubens
*Garden of Love*

Van Gogh
*Starry Night*